Angles of Vision
French Art Today

1986 Exxon International Exhibition

by Lisa Dennison

This exhibition is sponsored by Exxon Corporation. Additional support for the exhibition, which coincides with the centennial celebration of the Statue of Liberty, has been received from the Association Française d'Action Artistique.

Lenders to the Exhibition

Martine Aballéa
Bijan Aalam, Paris
Judith Bartolani
Marie-Claude Beaud
Marie Bourget
Farideh Cadot
Jean-François and Françoise Echard, Paris
Bernard Faucon
Philippe Favier
Michel Makarius, Paris
Patrick Tosani
Ethan J. & Sherry Remez Wagner, Sacramento,
California

Musée Cantini, Marseille
Fondation Cartier pour l'Art Contemporain,
Jouy-en-Josas
Fonds National d'Art Contemporain, Paris
F.R.A.C. Rhônes-Alpes, Lyon
Musée Départemental de Rochechouart, Limoges
Musée de Toulon
Georges Pompidou Art and Culture Foundation,
New York

Galerie Baudoin Lebon, Paris
Gabrielle Bryers Gallery, New York
Galerie Claire Burrus, Paris
Galerie Farideh Cadot, Paris
Castelli Graphics, New York
Galerie Liliane et Michel Durand-Dessert, Paris
Galerie de Paris

Library of Congress Cataloging-in-Publication Data

Dennison, Lisa.
 Angles of vision.

 "This exhibition is sponsored by Exxon Corporation.
Additional support for the exhibition, which coincides
with the centennial celebration of the Statue of Liberty,
has been received from the Association française
d'action artistique." "Solomon R. Guggenheim
Museum, New York."
 Includes bibliographies.
 1. Conceptual art—France—Exhibitions. 2. Art,
French—Exhibitions. 3. Art, Modern—20th century—
France—Exhibitions. 4. Artists—France—Biography.
I. Exxon Corporation. II. Association française
d'action artistique. III. Solomon R. Guggenheim
Museum. IV. Title.

N6848.5.C66D46 1986 709'.44'07401471
86-21979
ISBN 0-89207-058-7

Table of Contents

Preface and Acknowledgements

When the Solomon R. Guggenheim Foundation approached Exxon Corporation for financial support in the late 1970s, it was mutually agreed that the annual exhibition program would alternate between national and international presentations. Accordingly, we have observed and reported on current artistic developments in Britain, Italy and Australia, deciding each time that the creative activity and, in particular, the aspect concerned with its youthful production in the country of our choosing deserve special attention. The time has now come to revisit France and to offer a selection that, like the previous ones, does not attempt more than the projection of a personal view developed through repeated and conscientious efforts to grasp the meaning of the current artistic scene.

Angles of Vision: French Art Today is thus provided with the usual qualifying subtitles that are meant to limit pretentions rather than indicate tentativeness on our part; for the Museum continues to hold to its longstanding convictions about the effectiveness of a single selector, in this case Lisa Dennison, the Guggenheim's Assistant Curator. For the current show she has chosen ten artists who, expressing themselves in a variety of media, impressed her with the freshness, the conviction and the authenticity of their work.

The thanks of the Guggenheim Foundation are therefore extended, in the first instance, to Lisa Dennison, to her aides within and outside the Museum and to the artists, whose understanding and cooperation were essential for the successful completion of the project. That Exxon has continued its support over the years, often in the face of the criticism that almost inevitably befalls contemporary art selections, is to the Corporation's credit. It is equally appropriate to express our appreciation to the Association Française d'Action Artistique, especially Yves Mabin, for contributing to this undertaking. Jean-Marie Guéhenno, his successor, Marc Perrin de Brichambault, and Patrick Talbot at the French Consulate in New York have also been extremely helpful, and their efforts are gratefully acknowledged herewith.

Angles of Vision: French Art Today takes place in the year in which we celebrate the centennial of the Statue of Liberty. And while it is not our intention to burden the participants in the exhibition with coincidental responsibilities, the timing of the Exxon presentation may nevertheless be interpreted as the Guggenheim's solidarity with American and particularly with New York museums that felt impelled to salute the historic occasion.

Thomas M. Messer, *Director*
The Solomon R. Guggenheim Foundation

Among the many individuals whose collaboration was essential to the realization of this exhibition, I would like to single out Diane Waldman, Deputy Director, for her valuable advice on all phases of this project and for sharing her insights on contemporary French art with me; Diana Murphy, Editorial Coordinator, for her very skillful and conscientious editing of the catalogue; Carol Fuerstein, Editor, for her indispensable contribution to the publication as well; and Lisa Yokana, former Curatorial Assistant, and Nina Nathan Schroeder, Curatorial Assistant, for helping with the preparation of the show.

Sincere thanks are due to the many gallery dealers for their gracious cooperation, including Claire Burrus, Gabrielle Bryers, Farideh Cadot, Antoinette Castelli, Gérard Delsol, Michel Durand-Dessert, Eric Fabre, Catherine Issert, Marie-Hélène Montenay and Jean-François Taddei. Among the numerous museum directors and curators who introduced me to artists in their regions, and whose guidance and hospitality were most generous, I gratefully acknowledge Daniel Abadie, Marie-Claude Beaud, Bernard Blistène, Michel Bourel, Bernard Ceysson, Chantal Creste, Jean-Louis Froment, Françoise Guichon, Marie-Claude Jeune, Franz Kaiser and Suzanne Pagé. Other individuals whose assistance must be recognized include Ben, Victoire Buff, Catherine Ferbos, Manuela Masquelier, Juliette Salzmann, Geneviève Gallot and Vivienne Warszawski. A special acknowledgment is extended to those who have kindly lent works to the exhibition. And finally, I would like to thank the artists themselves for their enthusiastic commitment to all aspects of this show.

L.D.

Angles of Vision French Art Today

by Lisa Dennison

During the early 1980s in France, no movement emerged to rival the Neo-Expressionist style of Italy, Germany and the United States in terms of its international acceptance and influence; nor were French artists associated with this vanguard. Only a few isolated individuals from France achieved recognition on an international scale in the earlier years of this decade. Indeed, the small number of French participants in the major group exhibitions of contemporary art is a significant indicator of how little exposure recent French artists have received. For example, not one French artist was included among the younger exhibitors in The Royal Academy of Art's *A New Spirit in Painting* of 1981. Gérard Garouste was the only Frenchman among forty-six artists in the 1982 Berlin show *Zeitgeist*. That same year at *Documenta 7*, there were six French representatives among the 173 exhibitors; similarly, only eight out of 166 artists in The Museum of Modern Art's *An International Survey of Painting and Sculpture* of 1984 were French.[1] Most recently, the French found themselves without a participant in the *1985 Carnegie International*, and they fared only slightly better at home: in the *Nouvelle Biennale de Paris '85*, only twenty out of 120 artists were natives.

France's isolation from the international scene is not a recent phenomenon in the history of postwar art. After peace was restored in Europe, it was expected that Paris would remain the preeminent international art center and that the French masters, such as Picasso, Braque, Matisse and Léger, would continue to influence succeeding generations of artists worldwide. Yet many of the younger School of Paris artists remained rooted in tradition, while their counterparts in the burgeoning New York School were revolutionizing painting. Indeed, against the strength of the innovations of the Abstract Expressionists, French artists could no longer sustain Paris as the art capital of the Western world. A rapid succession of stimulating and prodigious movements of American art, including Pop Art, Color-Field Painting, Minimalism and Conceptualism exerted a powerful influence on European artists. This influence was for the most part not reciprocated by the French through the seventies. However, the sixties were marked by intense creative activity in France, and the impact of a number of individual French artists was felt in the United States during this decade.

The sixties in France were characterized by a diversity of artistic exploration. Geometric abstraction continued to flourish, and the investigation of movement, optical effects and light also gained new impetus, not only in France but worldwide. The dominant tendency of the period was *Le Nouveau Réalisme*; this term had been coined by art critic Pierre Restany in 1960 to describe the work of a group of artists, including Yves Klein, Arman, Jean Tinguely, Daniel Spoerri and César, who appropriated existing objects, particularly found materials from the urban environment, to make ironic comments on contemporary society. As Restany described their objective, "The act of pure appropriation is immediate; it aspires neither to the transcription nor the conceptualization of the object. By the sole fact of this gesture, the object transcends its quotidian and trivial existence and at the same time is liberated, thus attaining its full expressive autonomy...."[2] The purity that Restany speaks of was soon abandoned, however, as the artists altered their objects according to the aesthetic principles of their individual styles; and the broad range of interests of

these artists insured that their work thrived in an international context. Indeed, because of its relationship to Pop Art, with which it shared a concern with the world of objects and everyday events, as well as to the tradition of assemblage, *Le Nouveau Réalisme* was highly regarded in the United States.

In contrast, the impact abroad of the *Support/ Surface* movement of the seventies was slight. The French avant-garde of this decade took a more reflective stance in their art and thought. One of the persistent characteristics of postwar French art in general has been the element of theoretical discourse that is carried on in concert with the creative act. A contributing factor to the sustained interest in such discourse has been the impressive roster of intellectuals active in France during this period, including Jean-Paul Sartre, Claude Lévi-Strauss and Roland Barthes, whose writings have influenced the aesthetic preoccupations of younger artists. Structuralism, which gained popularity in the late sixties, was an especially strong current in Paris, particularly because of the privileged position accorded language and semiotics in French culture. In the search for a broader visual means of expression, artists and critics alike called upon semantics to analyze the role of art in the perception of reality.

The *Support/Surface* movement of 1969 to 1972 can be seen as an elaboration of these structuralist ideas. Though the movement itself was short-lived, its practitioners, among them Claude Viallat, Louis Cane, Daniel Dezeuze and François Rouan, continued to be active throughout the seventies. Their works were characterized by the repetition of shapes and colors on large unstretched canvases or other supports. As Otto Hahn wrote: "The structuralist trend of painting in France ... analyzes color,

brushstroke and composition. A painting becomes no more than canvas in the sense that it is no longer nailed to a stretcher but merely pinned to the wall. Any reference to illusion or staging was rejected. The important questions concerned the painting itself, its mode of production, the elaboration of codes, the relationship between the work and the wall from which it hangs."[3]

The group known as *B.M.P.T.*, formed by Daniel Buren, Olivier Mosset, Michel Parmentier and Niele Toroni, also adopted a more materialistic position with regard to their art. In rigorously minimal works they rejected the concept of art as illusion, maintaining that painting leads to no other reality than its own existence. Though *B.M.P.T.* was active only briefly, from 1966 to 1967, Buren's reputation developed on both sides of the Atlantic, based on his association with the international movements of Minimalism and Conceptualism. His signature works of alternating white and colored 8.7-centimeter-wide stripes acquire form and meaning from the contexts in which they are placed. In its dialectical rapport between the aesthetic sign and its environment, Buren's art questions the meaning of physical and mental structures, both tangible and intangible, encompassing the realms of history, politics, architecture and social institutions.

Jean Le Gac and Christian Boltanski are two other artists of the seventies whose works have conceptual underpinnings. Though their work has been tremendously influential in France, in particular on the younger generation of artists, it has not reached a wide audience, possibly because of the private and hermetic nature of their particular forms of expression. In addition, the two were working at a time when no movement, either in Europe or the United

States, achieved international preeminence. Both Boltanski and Le Gac use photography (Le Gac adds drawings and texts) and seek to reconstruct their own histories through memory. They explore the ambiguous relationship between art and reality, intending to prove that in the failure of representation to re-present the lived reality, art is, unavoidably, fiction. Although this is not a new aesthetic concept, it is a central question raised in French art now. In pursuing this issue, Boltanski, Le Gac and others have sought to dramatize the relationship between what is real and what is false through their art, a concern which has gained new relevance for many younger artists in France today.

A profound change in styles and a radical upheaval of values, constituting a reversal of the analytical and theoretical tendencies of the seventies, marked the dawn of a new decade in France. This change was heralded by the *Figuration Libre* group, whose nucleus was formed by Robert Combas and Hervé di Rosa and which was later expanded to include Rémy Blanchard and François Boisrond. These artists returned to figuration in dynamic paintings in which they gave free reign to their emotions and imaginations. Often sarcastic, witty or even naughty in tone, their imagery drew on popular culture as its source—in particular, rock music, cartoon strips, science fiction, television, movies and video. They cultivated a deliberately childlike, naive, even crude style that was akin in certain respects to American graffiti painting, although the artists cite points of reference closer to home: COBRA, Dubuffet and *L'Art Brut*. Though the work of the *Figuration Libre* group has not had a particularly strong international impact, its importance in having liberated a very young generation of French

artists from the austere minimalism of the previous decade cannot be underestimated. The notion of freedom inherent in the style is paramount. As one critic wrote: "Free! free . . . from theory and politics, from austere and calculated forms and suggested messages. Free from intellect and thought, from solemnity of life and culture, free from responsibility and morals; why not say from art, simply. . . . New wave, new speed, here comes 'bad painting.' To go fast, to express oneself quickly, to understand rapidly: the figure imposes itself."[4]

Since the early eighties, a different direction in painting, also figurative, has been explored in France. The artists working in this idiom, most notably Jean-Michel Alberola and Gérard Garouste, compose narrations that include mythological and art-historical references, which they then present in a conceptual framework. At the outset, what these artists shared with the *Figuration Libre* group was the desire to enter the international mainstream and participate in a dialogue with the prevailing Neo-Expressionist current. In this respect, their efforts have done much to awaken artistic life in France during this crucial period.

Yet another factor of extreme significance for French art, this time in the political arena, came into play early in the decade. The installation of François Mitterrand's Socialist regime in 1981, and his appointment of Jack Lang as Minister of Culture, has reverberated profoundly in creative realms in France, particularly in the domain of the visual arts. The emphasis of the Socialists' cultural policy has been to stimulate artistic creativity, in Mitterrand's words, "to give the people the power to invent, to imagine, to dream."[5] The instruments by which this was to be accomplished were, first and foremost, an

enormous increase in the budget for culture, and second, the decentralization of cultural resources. Ironically, Paris was consequently destined once again to lose its stature as the single artistic center, though this time on a national rather than international scale.

Decentralization was accomplished by a complex structure of state agencies. The Délégation aux Arts Plastiques (D.A.P.) was established to focus solely on contemporary art, under the direction of Claude Mollard, who subsequently founded the Centre National des Arts Plastiques (C.N.A.P.). The most important offshoot of these organizations, the Fonds d'Incitation à la Création (F.I.A.C.R.E.), has had the mission of opening new channels to bring contemporary art in the provinces to the attention of the public. To accomplish this goal, F.I.A.C.R.E. created the twenty-two Fonds Régionaux d'Art Contemporain (F.R.A.C.s), charged with assembling collections of contemporary art in their regions and with exhibiting these collections. The enlarged national arts budget also provided funding for France's inadequate system of art education—considered by some to be a fundamental cause of the problems faced by the art community—and an increase in the number of large-scale public commissions for artists.

Four years since their inception, the F.R.A.C.s have purchased over 6,000 works by 1,200 artists and initiated some 200 public commissions. While artists still gravitate to Paris, indisputably the primary cultural center of France, to find a stimulating community of peers who share their interests and to achieve recognition, artistic activities in France's regions are also flourishing, most notably in Bordeaux, Lyon, Saint Etienne, Marseille, Nîmes, Nice and Nantes. Though generally lauded for their ef-

forts, the F.R.A.C.s have had to bear the brunt of harsh criticism from the press and from art professionals regarding their acquisition policies, the extent of state involvement in cultural affairs, the lack of permanent facilities for the maintenance and display of these collections, and the wisdom of the philosophy of decentralization. Yet despite any reservations one might have with regard to the Ministry of Culture's programs, it is generally agreed that after only a few years, the signs that indicate a resurgence of a French vanguard are promising. There is certainly evidence of a restimulation of artistic activity through increased exhibition possibilities, a more active art market and a rejuvenated critical and aesthetic dialogue. The French question whether this will lead now to a new school of contemporary art. In recent years the lack of identifiably French movements or schools has been considered a detriment to the achievement of international recognition, whereas the specific national characteristics in German and Italian painting and New British Sculpture have served as a distinct advantage in this context. But the French notion of individualism remains strong: the younger artists, like their predecessors, appear to stalwartly refuse to be labeled, despite the fact that they have many common concerns.

However, regardless of the rejection of the notion of a collective identity, there is an aesthetic that is shared by a number of younger French artists. This aesthetic draws primarily (and very selectively) upon indigenous sources, yet reinterprets them in ways that are new and extremely creative. In particular, two tendencies in French art that are poles apart stylistically nourish the work of many artists today: the decorative and the theoretical. Several decora-

tive styles were born in France, from the ornate Rococco through Matisse's sensuous and lyrical drawing and color, and aspects of this tradition can be found in the recent work of numerous contemporary artists. Yet for many young painters, decorative is a pejorative term implying the absence of an intellectual base, and is thus synonymous with superficial or bourgeois attitudes. This contributes in part to the continued importance of Minimalist and Conceptualist ideas of the generation of the sixties and seventies on younger artists of the eighties active in all media. Their works reveal a persistent inquiry into the nature of art itself, and often use language as a basic tool in this endeavor. Similarly, the ideas of Dada and Marcel Duchamp, extremely important in the sixties, have renewed importance today, particularly for those artists investigating the area of the sculptural ''object.''

Even though these decorative and theoretical tendencies continue to preoccupy younger artists, what is new is that such attitudes are now tempered. For example, many artists work in reductive modes that do not have the austerity of Minimalism. The rigidity of Conceptual approaches has also been eased, so that ideas are often embodied in more demonstrative physical form, and infused, ultimately, with poetry, sentiment and emotion. Some artists draw on both the decorative and theoretical traditions, and appear to be striking a balance between these seemingly irreconcilable stylistic poles. Indeed, many of them have reformulated their attitudes toward decorative tendencies by reframing them in a more theoretical context. And painting, sculpture and photography are frequently combined, making the categorization of work increasingly difficult and, indeed, of less consequence.

The ten artists included in *Angles of Vision* represent only a small cross-section of the current artistic activity in France; they highlight, in particular, the original and inventive statements being made in the areas of sculpture, installation and photography. Although painting, in its strictest definition as oil or acrylic on canvas, is not featured here, several artists do use that medium as the foundation of their work, most notably, Philippe Favier, in his precisely rendered miniature paintings on paper or glass, and Georges Rousse, in his remarkable photographs of environments that have been transformed by paint. Judith Bartolani's richly worked surfaces, and the calligraphic silhouettes of what can best be described as drawings in space, partake of a painterly aesthetic, although her work is firmly entrenched in sculptural conventions. The ingeniously fabricated machines of Richard Baquié and the lyrical bas-reliefs and installations of Daniel Tremblay epitomize a very different aspect of a sculptural mode, prevalent in France today, that relies on commonplace objects. These objects and materials are combined and, by virtue of the interplay of their functional and poetic associations, transformed. Ange Leccia ''arranges'' objects, frequently machines, to set up simple relationships that bear strong emotional content. Tremblay, Leccia and Marie Bourget believe that the simplest means of expression is often the most evocative. Sometimes this quest for simplicity is nourished by memories of childhood experiences; the staged situations of Bernard Faucon's haunting photographs depend on such recollections as well. Bourget's abstract landscapes call on language to question notions of perception. In this regard, the seductive environments and accompanying texts of Martine Aballéa's instal-

lations also play on the capacity of language to convey the subtlest innuendo and implication, as do Patrick Tosani's photographs of falling rain interrupted by the artifice of plexiglass punctuation marks.

And finally, at the heart of much contemporary French art we find the enduring questions about the nature of reality and its relationship to art, explorations that depend on and continue the legacy of the artists of the sixties and seventies. To pursue these questions artists create "fictions"—situations that they either purely invent, or that are produced by their indirect intervention in conditions or circumstances that exist in daily life. A recent exhibition in Paris addressed the prevalence of fictional strategies in art now, and described this approach as ". . . a formal and mental device intervening in the articulation of space and language, sliding progressively into fiction by dissimulation, metaphorical semblance, pretence and other delusions, not the least being to present the literal itself as fictitious."[6] Thus, fiction continues not only to deceive, but also to reveal new truths in French art today.

Notes

1. The six French artists included in *Documenta 7* were Daniel Buren, Pierre Klossowski, Bertrand Lavier, Claude Rutault, Sarkis and Niele Toroni; at The Museum of Modern Art, France was represented by Jean-Michel Alberola, Jean-Charles Blais, Patrice Giorda, Toni Grand, Bertrand Lavier, Jean Le Gac, Patrice Saytour and Claude Viallat.

2. Maurice Eschapasse, "L'Avènement de l'objet" in *Douze Ans d'art contemporain en France*, exh. cat., Grand Palais, Paris, 1972, p. 61; reprinted from Pierre Restany, *Un Manifeste de la nouvelle peinture. Les Nouveaux Réalistes*, Paris, 1968, p. 57.

3. Otto Hahn, *Statements, New York 82, Leading Contemporary Artists from France*, exh. cat., New York, 1982, p. 7.

4. Marie-Luise Syring, "Infantilisme comme stratégie. Quelques réflexions sur la Figuration libre" in *Figures imposées*, exh. cat., Espace Lyonnais d'Art Contemporain, Lyon, 1983; reprinted in *French Spirit Today*, exh. cat., Fisher Art Gallery, University of Southern California, Los Angeles, and Museum of Contemporary Art, La Jolla, California, unpaginated.

5. Dore Ashton, "Cultural Soundings in France, 1983-84," *Arts Magazine*, vol. 58, January 1984, p. 116.

6. Suzanne Pagé, introduction to *Dispositif fiction*, exh. cat., A.R.C., Musée d'Art Moderne de la Ville de Paris, 1985, p. 3.

Martine Aballéa

In Martine Aballéa's universe, everything is false. And thus, everything is possible. The artist's inventive oeuvre encompasses installation pieces, photographs and books, and even more unconventional media such as posters, postcards and billboards, all of which simultaneously address the realms of the literary and the visual. Aballéa relies heavily on language, especially on its poetic resonances and metaphorical possibilities. She also manipulates language cleverly, playing upon spontaneous associations, ambiguities of meaning or the subversion of its explicative properties through the substitution of unexpected visual equivalents. In some instances the correspondence between word and image may be mutually reinforcing: the words underscore the images, and the images intensify the words.

The foundation of all of Aballéa's work is fiction. For example, in 1985 she executed a series of *Incomplete Novels (Romans partiels)* and posters for films that do not yet exist, which were exhibited with the enticing tag-line, "Coming soon to a theater [or bookstore] near you." For each book, only a cover design and a brief synopsis of the story exist: *The Wicked Architect (Le Méchant Architecte)* recounts the tale of a criminal architect who builds houses filled with traps. The film *Prisoner of Sleep (Prisonnière du Sommeil)* (cat. no. 8) is the story of a woman's desperate battle to keep her eyes open—for several years, she has not been able to awaken because her pillows are too soft, her sheets and blankets too comforting. *Fragrance of the Forgotten (L'Odeur de l'Oubli)* (cat. no. 6) involves a department store catastrophe in which several bottles of perfume are accidentally broken, creating a bizarre blend that wipes out the memories of all who sniff it. As the odor wafts through the air, the question,

"When will this wave of amnesia stop?" is ominously broadcast.

Aballéa's sensibility is closely linked to the Surrealist aesthetic. Her interest in the associations and implications of words as opposed to their literal meanings, for example, derives from the Surrealist canon. In some cases, these associations breed hilariously funny results, such as her fictitious postcard of 1978 for *The Elastic Hotel*, where "there's always enough room." Yet an enigmatic quality usually coexists with the humorous dimension of her works. Aballéa always records her dreams ("Their logic serves as a working tool for me."[1]) and has even published many of them in a book entitled *Midnight Avenue*. She says, "I love these precise but elusive images, similar to those seen in half-sleep."[2] Thus, the Surrealists' belief in the significance of dreams and the subconscious, which was inspired by the writings of Freud, is relevant to Aballéa's approach.

Installations constitute the main component of the artist's oeuvre, and this medium presents her with an ideal opportunity to exploit the Surrealist device of illogical or incongruous juxtaposition. These installations address "scientific fictions," for the most part, and often deal with the transformation or mutation of materials or beings, another basic concept of Surrealism. Though it specifically refers to the artist's installation *Nouveaux Phénomènes Naturels* at A.R.C. in Paris, Aballéa's introduction to the accompanying catalogue illuminates this particular leitmotif of her artistic production: "We believe we are living in a world where nature is stable, where matter, living beings and laws which determine their interaction exist. But nature is, in fact, in a state of constant transformation: stars are born and die,

continents shift, living beings continue to evolve. And occasionally, we witness the appearance of mutations whose causes we do not understand. These mutations give birth to new species, to new natural phenomena."[3]

Explanatory texts accompany Aballéa's installations: they are often couched in quasi-scientific terminology and liberally peppered with convincing but fabricated Latin classifications of genus, proper names and authoritative quotations from these fictitious individuals. The texts seem to close the gap between fact and fiction, but they leave us with a lingering doubt about the veracity of the situation the artist has created. In *The Temple of Lizards (Le Temple de lézards)*, for example, she tells us that the progress of modern biochemistry has led to the rediscovery of an ancient Mayan formula for a liquid that, when ingested by the extremely rare lizard *Lacerta aurea,* turns their bodies into gold. *Souvenir Gems (Bijoux-Souvenirs)* (cat. no. 2) confounds even more the rapport between art and reality by relying on the direct participation (and gullibility) of the viewer in a situation that exists outside the context of art. Here, Aballéa installed fake gemstones around one of the elevators that links the train platform to the street in the Jaurès metro station in Paris. A placard installed nearby cautioned riders that "the variations in pressure in this elevator can provoke the transformation of memories into mineral substances."

By creating environments whose ambience and materials are seductive and captivating — qualities often intensified by the glow of colored lights — Aballéa draws us into the magical world of her imagination. She invites us to ponder with her the inexplicable mysteries of life. With these works she

questions not only the ability of art to reveal new truths and to deceive at the same time, but the very nature of reality itself. As she explains, "I do not believe that there is a definite boundary between the real and the unreal, but rather a large fluctuating zone of possibilities. It is in this large zone that my stories are situated."[4]

See individual artist's bibliographies for complete references.

1. Fagnen, *Actuel*, 1982, p. 142.
2. Nuridsany, *Le Figaro*, 1980, unpaginated.
3. *Nouveaux Phénomènes naturels*, 1983, unpaginated.
4. Renard, *Art Press*, 1983, p. 33.

Biographical Information

Born in Roslyn, New York, August 11, 1950

Barnard College, Columbia University, New York, B.A. (Philosophy), 1971

London School of Economics, 1971-72

Moved to Paris, 1973

"Hors les Murs" Grant, Villa Medici, 1983

Fonds d'Incitation à la Création (F.I.A.C.R.E.), 1984

Lives and works in Paris

Selected Group Exhibitions

Galerie des Locataires, New York, 1974

Galerie du Centre Culturel Municipal, Villeparisis, *La Foire de l'estampe*, December 6, 1975-January 15, 1976. Catalogue

Los Angeles Institute of Contemporary Art, *Artwords and Bookworks*, February 28-March 30, 1978. Catalogue with texts by Mike Crane, Judith A. Hoffberg and Joan Hugo. Traveled to Artist's Space,

New York, June 10-28; Herron School of Art, Indianapolis, Indiana, September 15-29; New Orleans Contemporary Art Center, Louisiana, October-November

La Biennale di Venezia: Aperto 80, installation, "An Unknown Garden," May 28-September 30, 1980. Catalogue with texts by Harald Szeeman et al.

Galerie Gillespie-Laage-Salomon, Paris, *Artistes de la Biennale de Paris*, installation, "Habitants des nuits vertes," September 18-October 15, 1980

Musée d'Art Moderne de la Ville de Paris, *XI Biennale de Paris*, performance, "Café Crime," September 22-November 2, 1980. Catalogue

Studio 666, Paris, *6 Photografes*, November 6-30, 1980

American Center, Paris, *Livres d'artistes*, September 1981

Maison de la Culture, Chalon-sur-Saône, *7 Expositions d'hiver*, installation, "Flammes de plantes," January 23-February 21, 1982. Catalogue

American Center, Paris, *Récits immobiles*, installation, "Arbre à bijoux," April 14-May 15, 1982

Studio 666, Paris, April 22-May 29, 1982

Art Prospect, Paris (organizer), *Réseau art*, billboard, "Parfum, Poussière de Scandale," shown with posters and billboards commissioned for public display in France, June 1-15, 1982. Catalogue with texts by Jean-Louis Connan and Alain Garo

Maison de la Culture de Rennes, *Il n'y a pas à proprement parler une histoire...*, installation, "Le Temple des lézards," February 25-March 20, 1983. Catalogue with texts by Ramon Tio Bellido, Pascal Letellier and Pierre-Jean Valentin

Association pour l'Art Contemporain, Nevers, *Pour vivre heureux, vivons cachés*, installation, "L'Oiseau d'argent," May 30-June 30, 1984

Musée Saint Pierre, Art Contemporain, Lyon, *Collection 84*, installation, "Les Derniers Jours de Clinton Creek," October 4-November 12, 1984. Catalogue

American Center, Paris, *Quatre Français en Amérique*, April 17-June 30, 1985. Catalogue with text by Madeleine Deschamps

Musée National d'Art Moderne, Centre Georges Pompidou, Paris, *Livres d'artistes*, June 12-October 7, 1985. Catalogue with text by Anne Moeglin-Delacroix

Selected One-Woman Exhibitions

Galerie das Fenster, Hamburg, installation, *The Elastic Hotel*, February 1976

Franklin Furnace, New York, *Sleep-Storm Crystals*, January 21-February 10, 1978

P.S. 1, The Institute for Art and Urban Resources, Long Island City, New York, installation, *The Turquoise Zone Seduction*, December 3, 1978-January 21, 1979

Locus Solus, Genoa, installation, *Memorial Fish Laboratories*, March 10-April 10, 1981

A.R.C., Musée d'Art Moderne de la Ville de Paris, installation, *Nouveaux Phénomènes naturels*, March 15-April 24, 1983. Catalogue with text by the artist

Musée de Trouville, *Les Clichés de l'aventure*, August 15-September 30, 1984. Catalogue with text by Gilbert Lascault

Galerie d'Art du Centre Culturel de l'Université de Sherbrooke, Canada, October 12-November 17, 1985. Traveled to Musée du Bas-Saint-Laurent, Rivière-du-Loup, Canada, February 20-March 31, 1986

Selected Bibliography

By the Artist
Clam Holiday (handbill), Paris and New York, 1975
Triangle, Paris, 1977
Element Rage, Paris, 1979
Geographic Despair, Paris, 1979

On the Artist

Gloria Orenstein, "Exorcism, Protest, Rebirth: Modes of Feminist Expression in France. Part 1: French Women Artists Today," *Womanart*, vol. 2, Winter 1977-78, pp. 8-11

Peter Frank, "The Message Melds the Media," *The Village Voice*, February 13, 1978, p. 66

Michel Nuridsany, "Les Nuits vertes de Martine Aballéa," *Le Figaro*, October 3, 1980, p. 24

Anne Dagbert, "Martine Aballéa, Gloria Friedmann, Andréas Pfeiffer: Galerie Gillespie-Laage-Salomon," *Art Press*, no. 42, November 1980, p. 40

Nancy Wilson-Pajic, "Martine Aballéa, 'Green Nights,'" *Artforum*, vol. 19, January 1981, p. 79

Yanne Fagnen, "Douze Chambres de filles," *Actuel*, no. 27, January 1981, p. 142

Madeleine Deschamps, *Canal*, April-May 1982

Hervé Gauville, "L'Art d'accommoder les riens," *Libération*, April 7, 1983, p. 28

Anne Dagbert, "Aballéa, Bertholin, Gette, Rutault, Yalter, ARC," *Art Press*, no. 70, May 1983, p. 54

Delphine Renard, "Les Fictions scientifiques de Martine Aballéa," *Art Press*, no. 73, September 1983, p. 33

Michel Nuridsany, "L'Art vivant," *Le Figaro*, June 22, 1984, p. 29

Anne Dagbert, "Quatre Français en Amérique," *Art Press*, no. 93, June 1985, p. 64

Anne Moeglin-Delacroix, "Rêves d'artiste: A propos des livres de Martine Aballéa," *Nouvelles de l'Estampe*, no. 85, March 1986, pp. 27-29

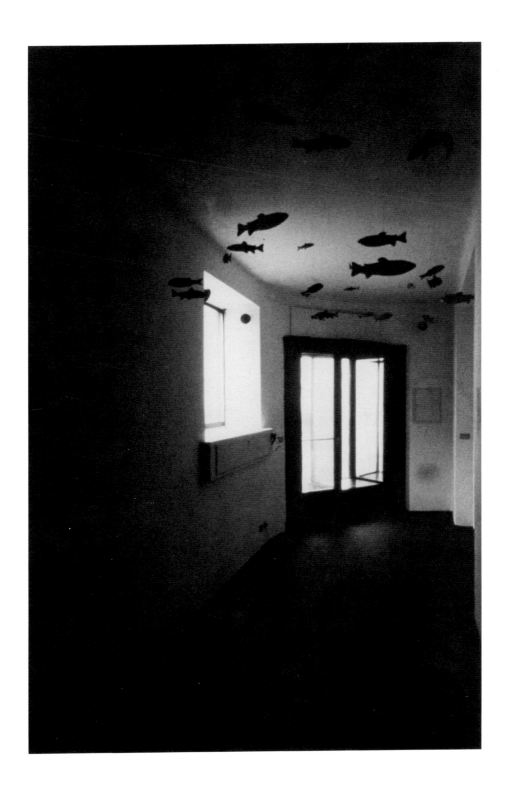

1 *Memorial Fish Laboratories.* 1981
Installation, Locus Solus, Genoa

We are testing a new method for registering memories of fish. This process is invisible and harmless. The longer you stay with us, the more information we will have for our archives. The only effect you may feel will be a heightened awareness of fish for a short while after this experiment.

Thank you for your collaboration.

2 *Souvenir Gems (Bijoux-Souvenirs).* 1981
Installation, Art Métro, Paris

In the "Jaurès" metro station there are elevators linking the train platforms to the street. Around the base of the street-level elevators, I spread glass emeralds, rubies, diamonds and sapphires. On the side of the elevators I affixed the following sign:

NOTICE

THE VARIATIONS IN PRESSURE

IN THIS ELEVATOR

CAN PROVOKE

THE TRANSFORMATION OF MEMORIES

INTO MINERAL SUBSTANCES

3 *Tree of Jewels (Arbre à Bijoux).* 1982
 Installation, American Center, Paris

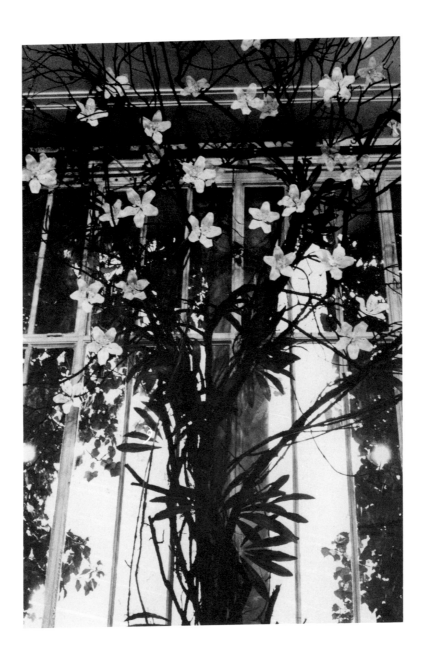

Tree of Jewels — Nor-Bu Siṅ-s Doṅ — Habitat : Tibet

This plant has the ability to assemble into crystalline structures the minerals it assimilates from the soil. Until the recent discovery of a few specimens, it was considered legendary.

The only other known reference to this plant is found in the book *Oriental Curiosities* by Sir Lewis Adams, explorer, who travelled throughout the Himalayas in the mid-XIXth century:

"The following day, towards noon, I descended into a valley so beautiful, and so full of flowers, that I was certain I had rediscovered Paradise lost. And among all these wonders of vegetation, I suddenly perceived one even more splendid than the others, for its blossoms imitated in every detail a bouquet of diamonds. I stood before it, deep in admiration, when, without warning, a dozen men sprung out of the bushes around me. They had the features of mountain people, they were scantily dressed, and they were green from head to foot. Without violence, they brought me to their village, and there I saw that the rest of the population was also entirely green. After having scrupulously searched and examined me, they allowed me to stay with them. I observed that they nourished themselves solely on water and the diamond-flowers, and that their principal occupation was the adoration of the sun. The very peculiar appearance and customs of these people intrigued me immensely, but my efforts to communicate with them remained unsuccessful. Thus I resolved to continue my journey.

"On the eve of my departure, one of the elders of the village, who spoke a few words of English, came to me and said: 'Here we eat the gem-flowers. It is a special food, for it transforms our bodies and enables us to absorb light, air, and water the same way vegetation does. We are plant-people, uniting in ourselves the different aspects of life and matter.' "

4 *The Last Days of Clinton Creek (Les Derniers Jours de Clinton Creek).* 1984
Installation, Musée Saint Pierre, Art Contemporain, Lyon

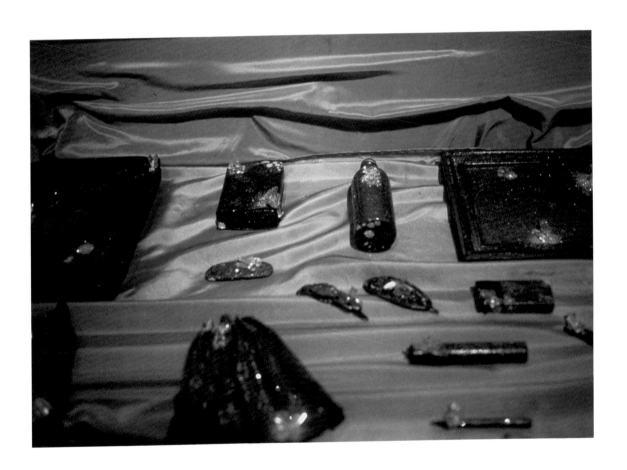

The town of Clinton Creek, territory of New Mexico, was founded in March 1871, on the day Horace J. Clinton discovered a silver vein there. The news travelled fast and, three months later, 1357 inhabitants had settled the area to profit from the riches of the land. Four years later, Clinton Creek had prospered and had become a veritable town, with six saloons, five stores, three hotels, a stable, a church, and a prison. Nothing in particular distinguished this community from the dozens of similar communities throughout the territory.

On the 21st of April 1875, however, the Santa Fe stagecoach stopped dead at the edge of the town, startled by a disconcerting scene: the buildings, the streets, and all the wagons were entirely covered with a thick greenish substance. Terrified, the drivers turned around and rode away at a gallop. They had almost reached Watrous, their next stop, when they were hailed by a panic-stricken man stained with the same green substance they had seen at Clinton Creek. He begged them to take him aboard so that he could tell the sheriff what had happened.

In the law-keeper's office the man told his story. On the preceding day, in the afternoon, a travelling "doctor" had set up his wagon on the main street. A small assembly had gathered around him as he praised the merits of his elixirs, unguents, and other miraculous products. He then presented a potion which he declared was even more spectacular. He claimed it had been personally given to him by a powerful Sioux medicine man. The potion in question was an extremely rare "liquid plant," which could grow rapidly anywhere. It was edible and possessed other properties that were even more remarkable. But he never got the chance to finish his speech: a drunken miner, who had already been laughing for a while at such exaggerated statements, started shooting at the bottles of "liquid plant." A fight broke out and the doctor fled, leaving behind his wagon and his vials, most of which now lay broken on the ground. As for the townspeople, they all had a good time. That evening, some of them had the impression that the puddles of "liquid plant" had grown, but no one took any notice of it.

The following morning, however, the town awoke to a pervasive horror: it had been invaded by the green substance; everything and everyone was covered with it. Hysterical, people ran screaming in all directions.

The sheriff of Watrous had listened carefully to the story, and the next day he took five of his best men with him to investigate the scene of these events. The green substance had disappeared, but now the ground, the buildings, and all visible objects were a dark, mat gray. There was no sign of life anywhere. Amid the grayness, though, the men thought they perceived bright sparkles. When they examined the town more closely, they saw that all the gray objects were encrusted with small diamonds.

Puzzled by this situation, the sheriff nevertheless thought of bringing back with him samples of objects from Clinton Creek. As for the inhabitants, no trace of them was ever found.

Few scientists have interested themselves in this phenomenon for lack of concrete data. In the thirties, however, some of them advanced the hypothesis that the green substance (which was never identified) must have modified the molecular structure of carbon, an element which is found in practically everything that surrounds us.

5 *Scandal Dust Perfume (Parfum, Poussière de*
 Scandale). 1982
 Billboard, 118 x 157½″
 Courtesy Art Prospect, Paris

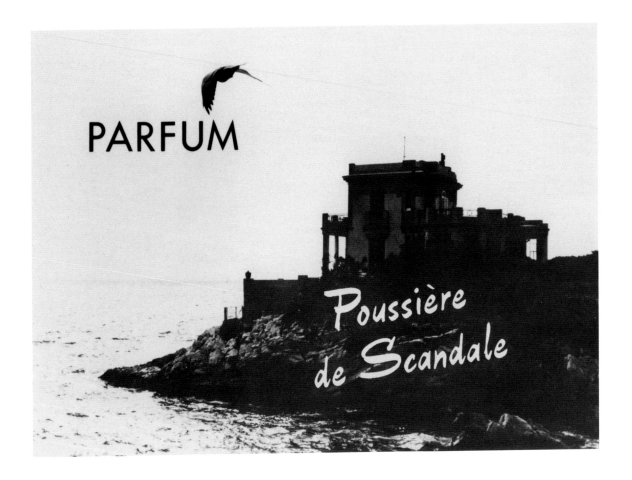

6 *Fragrance of the Forgotten (L'Odeur de l'Oubli).*
1985
Design for poster for film that does not yet exist,
hand-colored photograph, 27½ x 19¾"
Collection of the artist

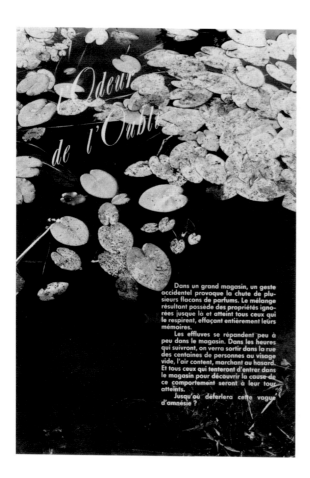

In a department store, an accidental movement causes several bottles of perfume to fall and break. The resulting mixture possesses properties hitherto unknown and affects all who breathe it, entirely erasing their memories.

Little by little, the emanations drift throughout the store. In the following hours, hundreds of people will be seen coming out into the street with blank faces, looking contented, walking aimlessly. And all those attempting to enter the store to discover the cause of this behavior will in turn be affected.

When will this wave of amnesia stop?

7 *A Mystery of the Frozen North (Un Mystère du Grand Nord).* 1985
Design for poster for film that does not yet exist, hand-colored photograph, 27½ x 19¾"
Collection of the artist

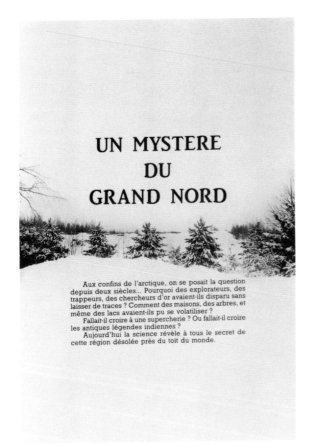

UN MYSTERE
DU
GRAND NORD

Aux confins de l'arctique, on se posait la question depuis deux siècles... Pourquoi des explorateurs, des trappeurs, des chercheurs d'or avaient-ils disparu sans laisser de traces ? Comment des maisons, des arbres, et même des lacs avaient-ils pu se volatiliser ?
Fallait-il croire à une supercherie ? Ou fallait-il croire les antiques légendes indiennes ?
Aujourd'hui la science révèle à tous le secret de cette région désolée près du toit du monde.

Along the borders of the Arctic, the question had remained unanswered for two hundred years: Why had explorers, trappers, and gold diggers disappeared without leaving a trace? How could houses, trees, and even lakes simply vanish?

Were we to believe a hoax? Or were we to believe the ancient Indian legends?

Today science reveals to all the secret of this desolate land near the roof of the world.

8 *Prisoner of Sleep (Prisonnière du Sommeil).* 1985
Design for poster for film that does not yet exist,
hand-colored photograph, 27½ x 19¾"
Collection of the artist

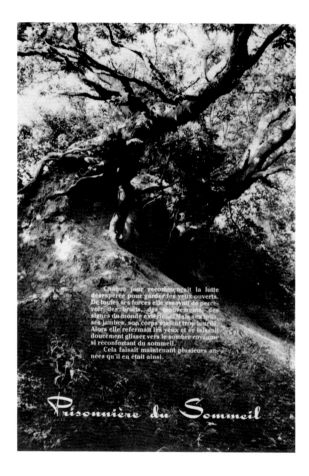

Each day began anew the desperate struggle to keep her eyes open. With all her strength, she would try to perceive noises, movements, or other signs from the outside world. But her arms, her legs, and her body were too heavy. And so she would close her eyes again and let herself drift softly towards the ever so comforting dark kingdom of sleep.

This situation had been persisting for several years now.

Richard Baquié

The process of recuperating and recycling discarded objects and materials, both mundane and sophisticated, is part of Richard Baquié's everyday life in Marseille. Inspired by the inherent properties of these found elements, by their forms and their functions, the artist combines them to create sculpture. By reorganizing them in this way, he simultaneously restores a sense of their former life and propels them into an entirely new realm. Movement is integral to these constructions, and the artist often incorporates sound, light and film to enhance their animation. These complex pieces are perhaps better defined as machines than as sculptures. As the artist explains, "I'm interested in all machines, ancient and contemporary, but I don't try to promote them. They interest me because of their movement, their capacity for creating stories. They stimulate mental projections in the spectator, force him to create associations, to open another space."[1]

There are several levels to Baquié's work, and taken together they form a whole in which the technological and the poetic interact with unusual harmony. The artist enjoys the functional and the aesthetic qualities of machines, and both are called on to participate in his sculptures. He uses operative motors, fans, projectors and record players, for example, to generate energy, wind, imagery, music and other sounds. These constructions are refined, yet they are also deliberately crude and makeshift in their juxtaposition of parts. Baquié does not disguise the mechanistic components—indeed, he exalts them for their formal properties, and allows them to coexist with sleeker, more conventionally aesthetic sculptural elements. The most important aspect of these pieces, however, is that in the grouping of disparate parts to form the larger object, new connections evolve and, consequently, a potent transformation of meaning occurs.

These machines are informed by an intensely poetic spirit. Their often lengthy titles and the persistent incorporation of language in the form of words and phrases into the structures of the pieces reinforce their poetic, communicative and contemplative dimensions. *Forgotten Passion (Passion oubliée)* (cat. no. 10), for example, consists of plaster letters that spell out the word "passion" placed on the floor. They are connected by a rudimentary yet strangely elegant rigging system of coiled plastic tubing to a basin of water—an old water storage tank from a multifamily dwelling in Marseille—to form an irrigation system. The circulation of water through this system suggests an alterative, perhaps alchemical process. The notions of the transformation of base materials into a more precious substance, and of distillation and purification are all invoked here, and recall the ideas of the Arte Povera artists. Joseph Beuys's sculptural articulation of organic functions in works such as *Honey Pump,* and his equation of the process of change with the process of life also come to mind.

Many of Baquié's earliest pieces involve airplanes. He says, "A plane for me is the most successful sculpture of all, defying gravity, not confined to a base."[2] The artist made use of various devices, including fans and solar cells, to keep these airplanes aloft (see cat. no. 9). The romantic notions of voyages and flight, both real and imaginary, are cultivated by him in works involving means of locomotion—planes, cars and trains. In *Formerly, He Often Took the Train to Transfer His Anxiety into Weariness (Autrefois, Il prenait souvent le train pour travestir son inquiétude en lassitude)* (cat. no. 11),

the artist appropriates a railway-car window which, in its open position, allows us to feel the wind generated by the fans within and thus simulates a sense of movement. Enigmatic and not immediately comprehensible in its bulky and cumbersome configuration, the sculpture nonetheless invites us to explore its hidden meanings.

Baquié's machines recall the French tradition of assemblage, as elaborated by the artists of Le Nouveau Réalisme. They are reminiscent of Tinguely's fantastical machines which combine assemblage and mechanical movement, as well as César's constructions using machine parts and his compressed automobiles, which raise questions about the effects of the machine age on civilization. Similarly, Baquié's use of modes of transportation as one of his principal subjects not only conjures up romantic associations but also raises specifically contemporary questions about space and time. He speaks of this issue as it is addressed in his work: "The basic question for me is that of my place in society's space, and this society's future as a whole in its movement and progress. To speak of time could be a romantic attitude For me, I speak of moving in space, of a synthesis between space and time. As such notions are hardly thinkable in the absolute, I construct fictional situations in order to generalize my questions, to universalize them."[3]

Yet another animating force in Baquié's oeuvre is the nostalgia for the lost time of youth. In Every Project Begins with a Story (Tout Projet commence par une histoire) (cat. no. 12), the artist convincingly replicates the experience of "cruising" in an automobile by situating his sculptural elements in such a way as to draw us in and make us physically feel what he remembers feeling in the situation that in-

spired the piece. Our senses are bombarded by the blaring music of the phonograph, meant to be the car radio; the powerful fans which suggest both the noise of the engine and the wind hitting us squarely in the face; and the dizzying film, projected on the far wall, which shows the view from the driver's seat as the car careens down a steep and winding road. The artist depends on our responsiveness to these sensations, as well as to the memories and associations they invoke. As one critic has noted of these pieces, "The dynamic expressed by the physical reality of animated and scenographic materials mimics the function of thought in its effort to grasp time and space. And it is within this atmosphere of immateriality that the game is essentially played."[4]

In a recent installation at A.R.C.A. in Marseille (cat. nos. 14-17) Baquié also re-creates the physical stimuli associated with cars. A Plymouth is cut into four sections and labeled North, South, East and West; their disposition in the exhibition space corresponds to these designations. In Plymouth West the section is placed so that we see its interior—windows and upholstered doors. Yet its exterior is mounted to a giant, electrically refrigerated metal arrow, so our view through the window is blocked by an imposing bank of frost and ice. The opposite sensation is evoked in Plymouth South: here, a concrete slab inscribed with the words "Amore mio" rests on the hood and is connected to a vat of boiling liquid that suggests an overheated radiator. The rear fragment, Plymouth North, alludes to the motion of the car and the sounds of cars, trains and the radio with a fan and stereo receiver, which filter their emissions through a long metal cylinder to the back seat. And in Plymouth East, a revolving wheel covered with a kaleidoscope of landscape images

projects through the left window. Characteristically, we are situated on the inside of the quartered car to maximize the impression of actual experience. Additionally, in this piece as in others, the wheels are removed from the automobiles and replaced with anonymous metal supports which immobilize them—in this case, the base of a sewing machine. Baquié strips the object of some of its literalness with this device. Propped up, it is rendered static despite the implications of rapid motion and, as such, participates more fully in a sculptural context. Baquié creates fictions with his machines, yet intermingles them with a reality so acute that they are projected into a mental and sensorial space that extends well beyond the physical confines of the exhibition environment.

1. *Art français: Positions*, 1986, p. 39.
2. Ibid.
3. Ibid.
4. Boué, *Des Arts*, 1986, p. 85.

Biographical Information

Born in Marseille, May 1, 1952

Ecole Régionale des Beaux-Arts et d'Architecture, Marseille-Luminy, Diplôme Nationale Supérieure d'Expression Plastique, 1981

Lives and works in Marseille

Selected Group Exhibitions

Ecole d'Art d'Aix-en-Provence, *Présence contemporaine*, July-August 1980

Images Actes Liés, Marseille, *Sculptures*, March 29-April 17, 1982

Espace Pierre Cardin, Paris, *Salon de Mai*, April 30-May 31, 1982

Centre Culturel d'Aubagne, *Jeunes Créateurs*, May 7-June 3, 1982

Musée des Beaux-Arts, Nîmes, *Volumes*, September 7-19, 1982

Images Actes Liés, Marseille, *Lieux d'artistes*, October 1-17, 1982

5°17 longitude Est, 43°16 latitude Nord, Marseille, *Opération rhinocérus*, March 8, 1983

Fondation Nationale des Arts Graphiques et Plastiques, Paris, *L'Après midi*, May 24-June 10, 1983. Catalogue

Musée Sainte-Croix, Poitiers, *Symposium*, June-August 1983. Catalogue with texts by Josée Escudier and Didier Semin

A.R.C.A. (Action Régionale pour la Création Artistique), Marseille, *Octopus*, September 6-October 15, 1983. Catalogue

F.R.A.C. Provence-Alpes-Côte d'Azur, Marseille (organizer), *Fonds régional art contemporain, 1982-1983*, Musée Cantini, Marseille, 1983. Catalogue

Galerie Axe Art Actuel, Toulouse, *Installations*, January 17-February 7, 1984

Musée des Beaux-Arts de Chartres, *Nouveaux Objets illustratifs ou le crève-coeur en 1984*, March 24-April 28, 1984. Catalogue with text by Patrice le Nouëne and statements by the artists

Fundació Joan Miró, Barcelona, *Epure si Muove*, April 11-May 6, 1984

Nice, *Présentez art*, July 3-10, 1984

Maison de la Culture, Albi, *Siméon et les flamants roses: Jeune Sculpture européenne,* July 10-August 31, 1984. Catalogue with texts by Patrice Bloch, Achille Bonito Oliva, M. Fernandez-Cid, Marc Partouche and Laurent Pesenti

F.R.A.C. Pays de la Loire, Fontevraud (organizer), *I Ateliers internationaux de Fontevraud*, Abbaye Royale de Fontevraud, October 27-December 11, 1984. Catalogue with texts by Michel Enrici, Bernard Martin et al.

Musée Cantini, Marseille, *Fonds régional d'art contemporain*, November 1984. Catalogue. Traveled to Fondation Maeght, Saint Paul-de-Vence, March 1985

F.R.A.C. Midi-Pyrénées, Toulouse (organizer), *Sagas, versant sud: Parcours dans l'art d'aujourd'hui de Bordeaux à Nice*, Palau Meca, Barcelona, June 18-July 28, 1985. Catalogue

Gracie Mansion Gallery, New York, *Galerie Eric Fabre at Gracie Mansion*, June 20-July 13, 1985

Hôtel de Matignon, Paris, *Sculptures*, June 20-July 6, 1985. Catalogue

Fort Saint Alban, Nice, *Cartes et châteaux*, July 1985

Galerie Arlogos, Nantes, *G. Autard, R. Baquié, R. Monnier, G. Thupinier*, October 5-26, 1985

Fondation Cartier, Jouy-en-Josas, *Sculptures*, October 1985-January 1986. Catalogue

Centre de Création Contemporaine, Tours, *France-Tours, art actuel: Deuxième Biennale nationale d'art contemporain*, November 29, 1985-January 6, 1986. Catalogue with texts by Didier Larnac, Loïc Malle, Philippe Piguet, Delphine Renard and Jérôme Sans and interview with Skimao by Christian Laune

F.R.A.C. Midi-Pyrénées, Toulouse (organizer), *Itinéraires du versant sud*, Centre Régional d'Art Contemporain, Toulouse, December 3, 1985-February 23, 1986. Catalogue

Musée Cantini, Marseille, *Acquisitions 82-85 du F.R.A.C. Provence-Côte d'Azur*, December 1985. Catalogue

B.I.G. Berlin, *Art français: Positions,* February 8-23, 1986. Catalogue with texts by Jean de Loisy and Hans-Peter Schwerfel and interviews with the artists by Philippe Cyroulnik, Jean de Loisy, Paul-Hervé Parsy and Joëlle Pijaudier

Centre Régional d'Art Contemporain Midi-Pyrénées, Toulouse, *Variétés-jeux d'objets*, March 12-April 6, 1986

Fondation Nationale des Arts Graphiques et

Plastiques, Paris, *Créations pour un F.R.A.C. (Pays de la Loire)*, April 29-June 8, 1986

Amsterdam, *Kunst Raï 86*, June 4-8, 1986. Catalogue

Maison de la Culture de Rennes, *Festival des Arts Electroniques*, June 6-30, 1986. Catalogue

Selected One-Man Exhibitions

Galerie Eric Fabre, Paris, September 20-October 15, 1984

Galerie Arlogos, Nantes, May 4-July 8, 1985

A.R.C.A. (Action Régionale pour la Création Artistique), Marseille, December 16, 1985-February 9, 1986. Catalogue with text by Michel Enrici

Selected Bibliography

By the Artist
Public, no. 3, 1985, p. 64

On the Artist
Lise Ott, "Octopus," *Art Press*, no. 75, November 1983, p. 48

Marc Partouche, "Albi," *Axe Sud*, no. 13, Summer 1984

Christian Schlatter, "L'Art des récits privés (II)," *Artistes*, no. 20, Summer 1984, pp. 98-103

"Siméon et les flamants roses," *Mars*, no. 6, Summer 1984, pp. 38-40

Patrick Krebs, *Flash Art* (France), no. 6, Winter 1984-85

Frédéric Durand-Ferchal, "L'Amérique redécouvre la France," *L'Art Vivant*, no. 10, March-April 1985, pp. 20-21

Delphine Renard, "Sagas, Palau Meca," *Art Press*, no. 95, September 1985, p. 60

Brigitte Cornand, "Avec ses drôles de machines soufflantes, ronflantes," *Actuel*, no. 74, December 1985, p. 195

Marc Partouche, "Visite chez Richard Baquié,"
Mars, no. 7-8, Winter 1985-86, pp. 2-5

Catherine Grout, "Sculpture in France," *Flash Art*
(International), no. 125, December 1985-January
1986, pp. 66-69

Philippe Piguet, "Richard Bequié: Le Temps de
rien," *L'Evénement*, no. 63, January 16-22, 1986,
p. 114

Henri-François Debailleux, "Portrait: Richard
Baquié," *Beaux-Arts Magazine*, no. 32, February
1986, pp. 74-76

Jean-Louis Marcos, "Richard Baquié," *Art Press*,
no. 100, February 1986, p. 81

Sicard Bergeron, *Art Thème,* no. 32, March 1986,
p. 24

Caroline Clement and Philippe Nottin, "Le Temps
de rien," *Kanal*, no. 17-18, March 1986, pp. 22-23

Brigitte Cornand, "Vive le génie," *Actuel*, no. 77,
March 1986, pp. 88-89

Catherine Grout, "Sculptures," *Flash Art* (France),
no. 10, March 1986, p. 38

Catherine Grout, "L'Enfance de l'art," *Axe Sud*,
no. 16, April 1986, p. 22

Maïten Bouisset, " 'Variétés-Jeux d'objets,' "
Art Press, no. 103, May 1986, p. 68

Marie Boué, "Primitivisme et nouvelles technolo-
gies," *Des Arts*, no. 2, Spring 1986, pp. 83-85

Jean-Louis Marcos, "Le Cabanon et L'ESPACE-
TEMPS," *Art Press*, no. 104, June 1986, p. 39

Anne Richard, "Sculpture/Objet/Image 1985, Mort
d'un Espace de Fiction," *Opus*, no. 99, Winter 1986,
pp. 18-23

9 *Wind Situation III (Situation du vent III).* 1983
 Plastic bags, wood, grass and fan, 78¾ x 39⅜ x 39⅜"
 Courtesy Galerie de Paris

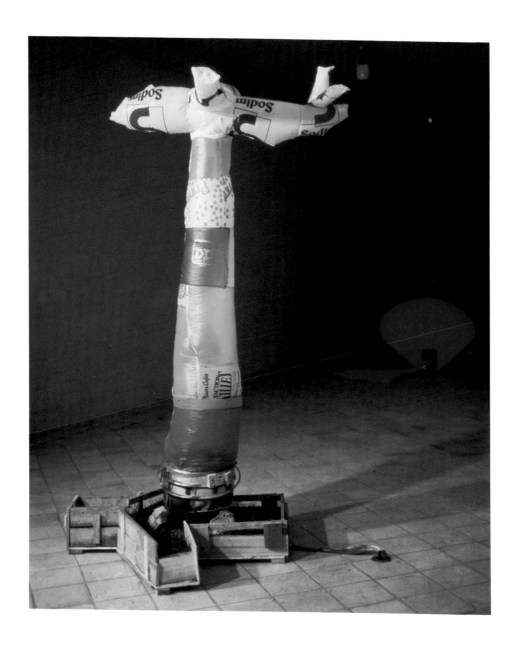

10 *Forgotten Passion (Passion oubliée).* 1984
Plaster, plastic tubes, motor, metal, wood, water
storage tank and water, 48 x 94½ x 150″
Collection Ministère de la Culture-Direction
Régionale des Affaires Culturelles des Pays de la
Loire-Centre Culturel de l'Ouest

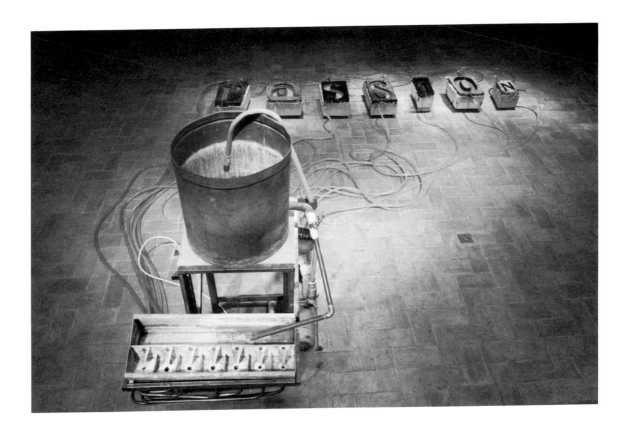

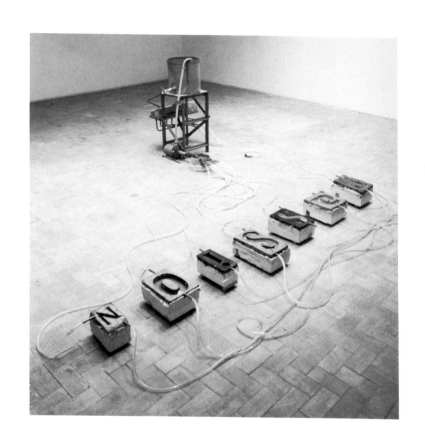

11 *Formerly, He Often Took the Train to Transfer His Anxiety into Weariness (Autrefois, il prenait souvent le train pour travestir son inquiétude en lassitude).* 1984

Metal, railway-car window, fans, cloth and LED sign, 72⅞ x 125¹⁵⁄₁₆ x 36⁹⁄₁₆"

Collection Musée National d'Art Moderne, Centre Georges Pompidou, Paris

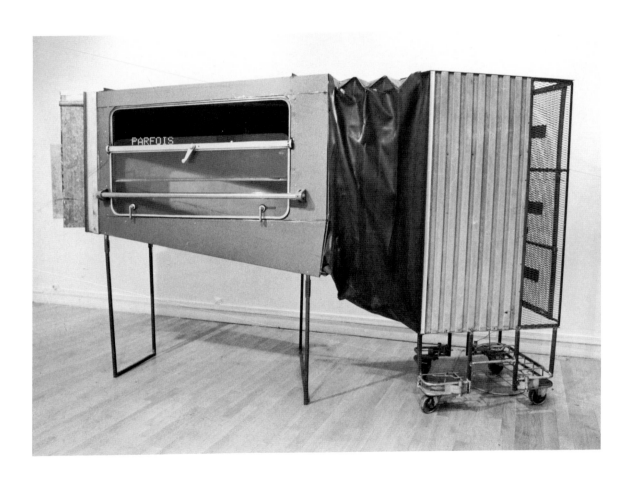

12 *Every Project Begins with a Story (Tout projet commence par une histoire)* (detail). 1985

Metal, section of automobile frame, phonograph, fans, film projector and film, 67 x 50 x 23⅝"

Collection Fondation Cartier pour l'Art Contemporain, Jouy-en-Josas

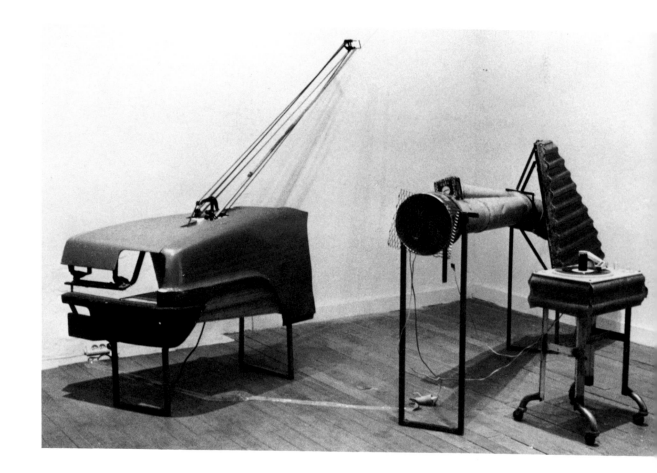

13 *Untitled (Sans titre).* 1985
Chair, cardboard letters and metal, 48⁷⁄₁₆″ high
Collection Stedelijk Van Abbemuseum, Eindhoven,
The Netherlands

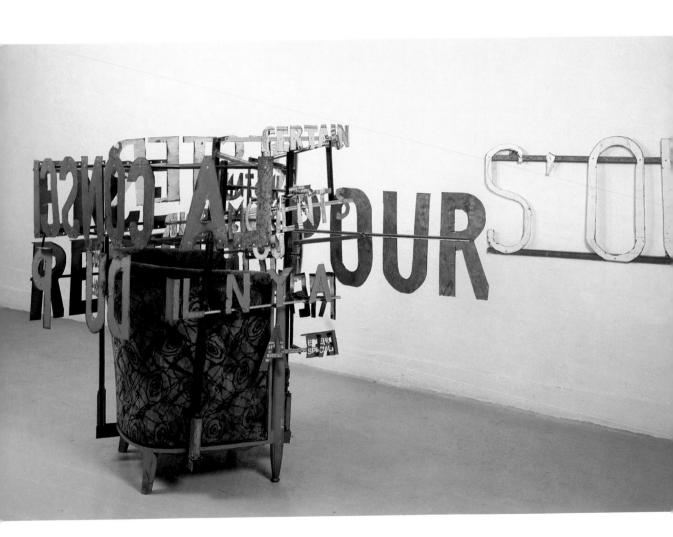

14 *Plymouth East (Plymouth Est).* 1985
Automobile door, metal, wood, strobe light and
photographs with ink drawings, 87⅜ x 91⅝ x 39⅜″
Collection Roger Pailhas, Marseille

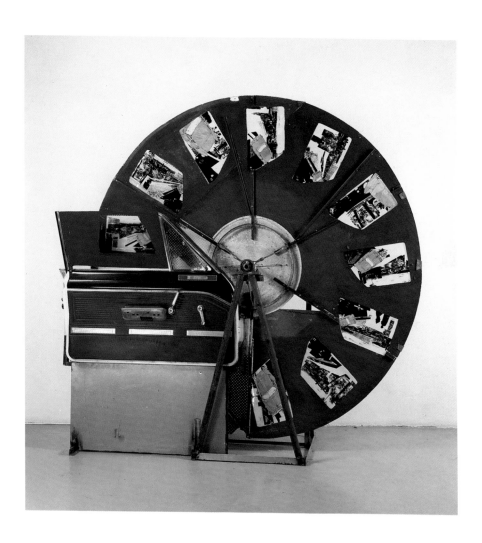

15 *Plymouth South (Plymouth Sud).* 1985
Front of automobile, concrete, metal, tar, rubber and
water, 56⅞ x 76⅞ x 69¼″
Collection Roger Pailhas, Marseille

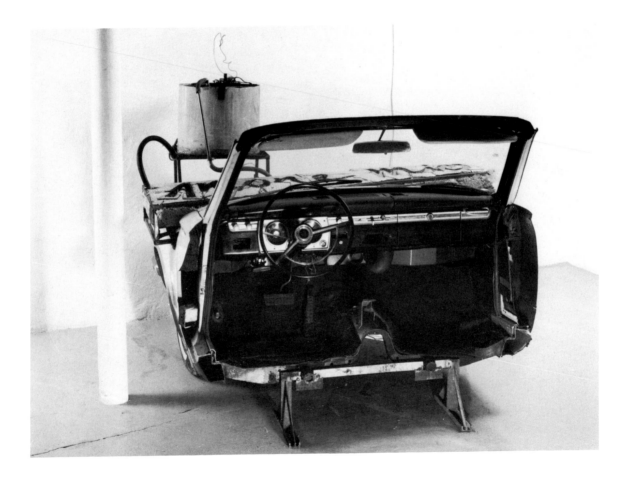

16 *Plymouth West (Plymouth Ouest).* 1985
 Right side of automobile, metal, electrically re-
 frigerated metal element and ice, 59 x 120 x 25½″
 Collection Roger Pailhas, Marseille

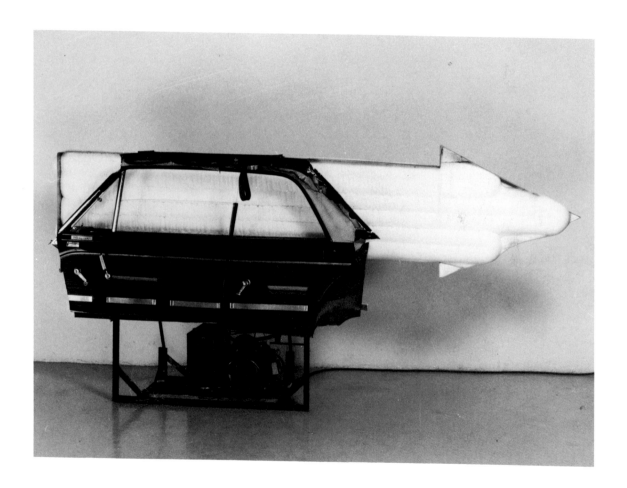

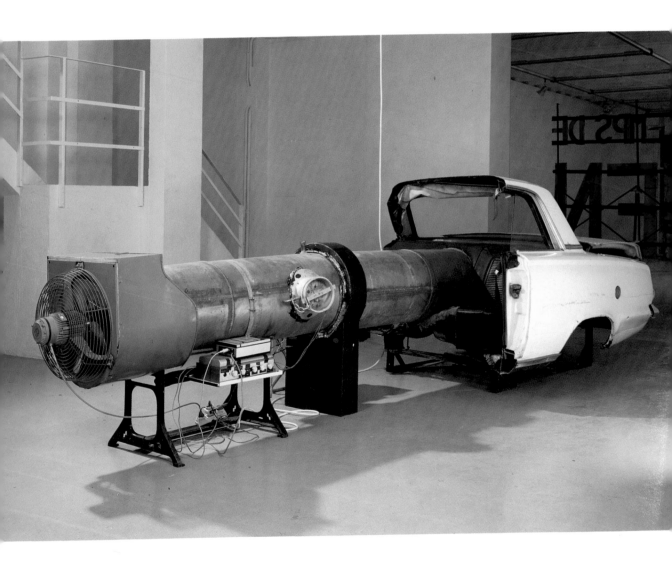

17 *Plymouth North (Plymouth Nord).* 1985
 Rear of automobile, fan, metal, speaker and car
 radio, 54¼ x 180½ x 69¼"
 Collection Roger Pailhas, Marseille

Judith Bartolani

Judith Bartolani stands somewhat apart from a number of sculptors of her generation who are preoccupied with the notion of the object. She states that, to the contrary, her primary concern is with space. The spatiality of sculpture has traditionally derived from the existence of volume, but for Bartolani, spatial considerations stem from a point of origin that is instead two-dimensional. To create volume she uses drawing, not to make preliminary sketches on paper to be realized in three dimensions, but actually to form the foundation and structure of the work. In this respect, Bartolani follows the important tradition of sculptors, most notably Julio González and David Smith, who literally draw in space. However, the iron and steel of González, Smith and their followers readily lend themselves to open, linear construction, whereas Bartolani's more unorthodox materials, which are those of the automobile and aerospace industries, pose unusual challenges for the sculptor.

What in essence becomes a drawing in space begins as a drawing on the ground. Using the studio floor as her work space, the artist employs carbon fibers as line, and epoxy and polyester resin and fiberglass as the binding support, which she often embeds with particles of stone, metal, charcoal or plaster, to create built-up surfaces of textured relief. The carbon fibers serve as an armature, visual rather than structural, and give a strong linearity to the forms of the works; yet they also function more lyrically to enliven these pieces with a rhythmic calligraphy. Bartolani enhances this calligraphic effect by drawing in charcoal or pastel on the surface of the other materials. Thus drawing, in more than one guise, is integral to the sculptural process. Additionally, although they are three-dimensional objects, the pieces are treated as having two primary sides instead of many, and each side is worked in a completely autonomous manner. As Bartolani explains, "It will be another drawing inspired by the same form yet with a different sensibility, because it is a different moment, a different feeling."[1]

When the two sides of the sculpture have been completed, the piece is righted. The question of how this thin but heavy object will stand brings another set of considerations to bear, and each piece requires a different solution. Because the works tend to be off-balance from their natural centers of gravity, they seem unstable; the artist deliberately maintains this vital tension suggested by their tenuous equilibriums while enabling them to stand on their own. To provide balance she uses javelin-like metal projections, free-form stone bases or flat, flipper-like extensions that hug the floor. The sculptures seem to defy not only effects of equilibrium, but effects of weight as well. In recent works such as *Gymnast with Pumice Stone (La Gymnastique à la pierre ponce)* (cat. no. 25b), Bartolani inverts the traditional relationship between light and heavy, so that volcanic rocks or pumice stones are balanced on the upper portions or in the centers of the wafer-thin sculptures. How these rocks are supported is mystifying: the visual sensations they create are totally at odds with the properties of their materials.

Bartolani's works display a grandeur and monumentality in their massive planarity, but at the same time, they retain a human scale. The artist says, "I always work in terms of walking around the sculpture (and even within it, mentally). It is this concern with human scale that leads me back to an interior space, to a kind of architectural space."[2] Despite

the fact that they are essentially planar, the sculptures force us to consider them from all angles because their profiles change as we walk around them. Opaque areas of a piece are given an opaline finish that gleams like the inside of an oyster shell. In contrast, the translucent epoxy resin and the loosely gathered carbon fibers let light penetrate and allow us actually to look through the sculpture; and the larger negative or cutout areas also permit a view through the work. These elements create a play between solid and dissolved form in which the surrounding space is activated and thereby transformed.

The artist has been inspired by her travels around the Mediterranean to places such as Greece, Crete, Spain and Italy. The pure forms and proportions of architecture she has seen have been particularly influential. She explains, "I often start from architectural forms, a building, a plaza, an arcade, in Italy, for example, or in Greece. First, I perceive the architecture as a form-mass on a plane, as an idea or as impressions which I transcribe into drawings that, progressively simplified and reduced to essentials, are the starting point of my sculpture."[3] Perhaps further evidence of her dependence on architecture as a source are the surfaces of her works, which often have a rough, encrusted texture reminiscent of ancient, crumbling walls.

Though Bartolani's sculptures are abstract, their dynamic silhouettes frequently evoke recognizable images. In *The Band of Four (La Bande des quatres)*, for example, an installation of four sculptures presented at A.R.C.A. in Marseille in 1984 (cat. nos. 21, 22), the impression of giant calligraphy is overwhelming. Yet these gestural black forms also suggest schematic drawings of a tree, two houses and a television set. Similarly, in a 1985 work, *Little Temple (Petit Temple)* (cat. no. 25a), the form of the house is again suggested, though here the black outline inscribes a richly worked interior highlighted with glimmering silver and gold pastel. In contrast to the stark angularity of these works, others are endowed with the fluid and organic contours of ellipses, disks and spirals.

Bartolani's sculpture thrives on paradox and contradiction. Her materials are at the same time dense and translucent; their seeming fragility and weightlessness belie great strength and heaviness. Standing, they are precarious but remarkably stable. Their contours seem to store great reserves of energy, yet at times they spring open like giant coils to expel their force. These are extremely powerful works, yet their strength and rigor coexist with grace and elegance.

1. Valabrèque and Partouche, *Mars*, 1985, p. 10.
2. Malle and David, *Judith Bartolani, Sculptures*, 1984, unpaginated.
3. Ibid.

Biographical Information

Born in Haifa, July 5, 1957

Ecole Régionale des Beaux-Arts et d'Architecture, Marseille-Luminy, Diplôme Nationale Supérieure d'Expression Plastique, 1979

Prix d'Elf Aquitaine, Société Elf Aquitaine, Paris, 1983

Lives and works in Marseille

Selected Group Exhibitions

Maison des Arts, Créteil, *Situations art-régions*, September 1980

Maison de la Culture, Villeparisis, *Travaux sur papier objets*, December 1980

Chapelle des Cordeliers, Avignon, *Midi et demi*, July 1981

Images Actes Liés, Marseille, *Sculptures*, March 29-April 17, 1982

Galerie Athanor, Marseille, June 1982

Salon de la Jeune Sculpture, Paris, September 1982. Catalogue

Parc Chanot, Marseille, *Action création*, October 1982

Musée Cantini, Marseille, *Marseille art présent*, March 30-April 30, 1983

Musée des Monuments Français, Paris, *Expression sculpture*, October 1983

F.R.A.C. Provence-Alpes-Côte d'Azur, Marseille (organizer), *Fonds régional art contemporain, 1982-1983*, Musée Cantini, Marseille, 1983. Catalogue

Maison de la Culture, Albi, *Siméon et les flamants roses: Jeune Sculpture européenne*, July 10-August 31, 1984. Catalogue with texts by Patrice Bloch, Achille Bonito Oliva, M. Fernandez-Cid, Marc Partouche and Laurent Pesenti

Kunstlerhaus, Hamburg, *Nous vivons tous aux bord de la mer*, July 1984

Im Klapperhof 33, Cologne, *Les Six Portes de Babel*, November 1984. Catalogue

Musée Cantini, Marseille, *Fonds régional d'art contemporain*, November 1984. Catalogue. Traveled to Fondation Maeght, Saint Paul-de-Vence, March 1985

Musée André Malraux, Le Havre, November 1984. Catalogue

Renault Art et Industrie, Centre International de Création Artistique, Sandouville, *Scuptures dans l'usine*, November 1984. Catalogue

Centre National des Arts Plastiques, Paris (organizer), *Le Style et le chaos*, Musée du Luxembourg,

Paris, March 1-April 30, 1985. Catalogue with text by Jean-Louis Pradel

F.R.A.C. Champagne-Ardenne, Epernay, *Carta*, April 20-May 1, 1985. Catalogue

F.R.A.C. Midi-Pyrénées, Angers (organizer), *Sagas, versant sud: Parcours dans l'art d'aujourd'hui de Bordeaux à Nice*, Palau Meca, Barcelona, June 18-July 28, 1985. Catalogue

Fondation Cartier, Jouy-en-Josas, *Sculptures*, October 1985-January 1986. Catalogue

Centre de Création Contemporaine, Tours, *France-Tours, art actuel: Deuxième Biennale nationale d'art contemporain*, November 29, 1985-January 6, 1986. Catalogue with texts by Didier Larnac, Loïc Malle, Philippe Piguet, Delphine Renard and Jérôme Sans and interview with Skimao by Christian Laune

F.R.A.C. Midi-Pyrénées, Angers (organizer), *Itinéraires de versant sud*, Centre Régional d'Art Contemporain, Toulouse, December 3, 1985-February 23, 1986. Catalogue

Gabrielle Bryers Gallery, New York, May 1986

Selected One-Woman Exhibitions

Galerie Med à Mothi, Montpellier, January 1983

Musée de Toulon, *Carte Blanche à François Bazzoli*, June 16-30, 1983. Catalogue with texts by François Bazzoli, Marie-Claude Beaud and Jean-Pierre Coscolla

Galerie Gabrielle Maubrie, Paris, *Judith Bartolani, Sculptures*, May 1984. Catalogue with text by Loïc Malle and interview with the artist by Catherine David

A.R.C.A. (Action Régionale pour la Création Artistique), Marseille, *Judith Bartolani*, January 14-February 23, 1985. Catalogue with texts by Alin Alexis Avila and Loïc Malle

Galerie Catherine Issert, Saint Paul-de-Vence, June 1985

Gabrielle Bryers Gallery, New York, February 8-March 1, 1986

Selected Bibliography

Nicolas Zafran, "Judith sculpte l'énergie,"
Le Sud, June 1983, pp. 70-71

Marc Partouche, "Les Sculptures de Judith
Bartolani, L'Opale," *Axe Sud*, no. 9, Summer 1983

Marc Partouche, "Notes sur Judith Bartolani,"
Axe Sud, no. 12, Summer 1984

"Siméon et les flamants roses," *Mars*, no. 6,
Summer 1984, pp. 38-40

Bernard Cambon, "Jeune Sculpture contempo-
raine," *Art Press*, no. 84, September 1984, p. 60

Loïc Malle, "Les Elans mystiques de Judith
Bartolani," *Art Press*, no. 84, September 1984, p. 19

Jean-Louis Marcos, "Judith Bartolani à l'ARCA:
La Calligraphie de l'espace," *Le Provençal*,
January 17, 1985, p. 6

Loïc Malle, "Judith Bartolani, Marie Jo Lafontaine,
ARCA," *Art Press*, no. 90, March 1985, pp. 66, 68

Françoise Bataillon, "Le Style et le chaos," *Art
Press*, no. 92, May 1985, p. 66

Frédéric Valabrègue, "La Bande des 4 . . . ," *Mars*,
no. 5, Spring 1985, p. 9

Frédéric Valabrègue and Marc Partouche, "Entre-
tien avec Judith Bartolani," *Mars*, no. 5, Spring
1985, pp. 10-11

Catherine Grout, "Bartolani, Campano, Lacalmontie,
Noël, Resal," *Flash Art* (France), no. 7-8, Spring-
Summer 1985, p. 46

Patrick Redelberg, " 'Carta,' " *Art Press*, no. 93,
June 1985, p. 54

Delphine Renard, "Sagas, Palau Meca," *Art Press*,
no. 95, September 1985, p. 60

Mona Thomas, "Judith Bartolani, Portrait," *Beaux-
Arts Magazine*, no. 30, December 1985, pp. 88-89

Catherine Grout, "Sculpture in France," *Flash Art*
(International), no. 125, December 1985-January
1986, pp. 66-69

Catherine Grout, "Sculptures," *Flash Art* (France),
no. 12, March 1986, p. 38

Michèle Cone, "Judith Bartolani: Gabrielle Bryers,"
Flash Art (International), no. 127, April 1986, p. 70

"Gabrielle Bryers Gallery, Judith Bartolani,"
Galeries Magazine, no. 11, April 1986, p. 40

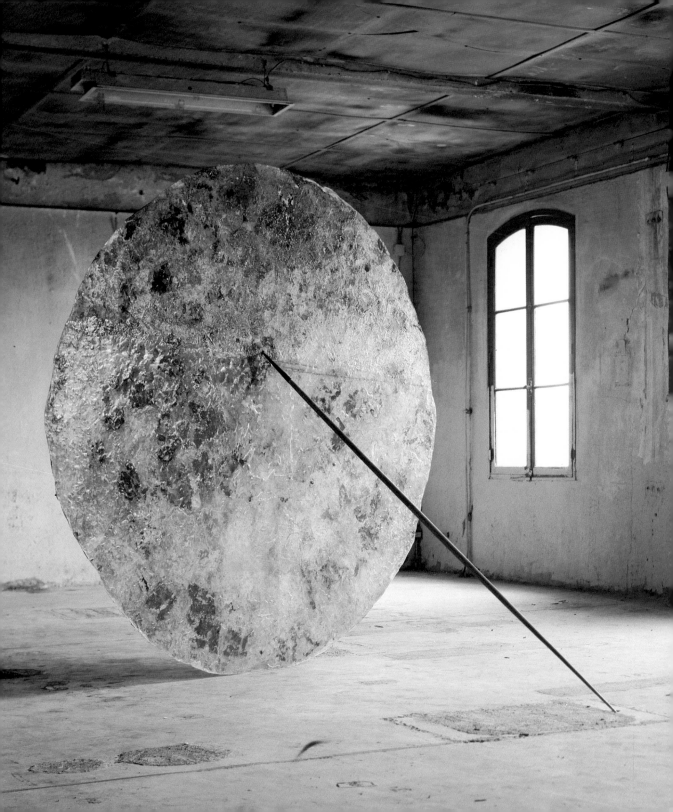

18 *Large Disk with Javelin (Grand Disque avec javelot).*
1983

Fiberglas, resin, burned fabric, plexiglass and
javelin; disk, 98⅜″ diameter, ⅛″ deep, javelin,
106¼″ long

Courtesy Galerie Farideh Cadot, Paris

19 *Large Ellipse (Grande Ellipse).* 1983
 Fiberglas, carbon fibers, plexiglass, steel, resin,
 mirror and pastel, 98 x 118⅛ x ⅛″
 Collection F.R.A.C. Midi-Pyrénées, Toulouse

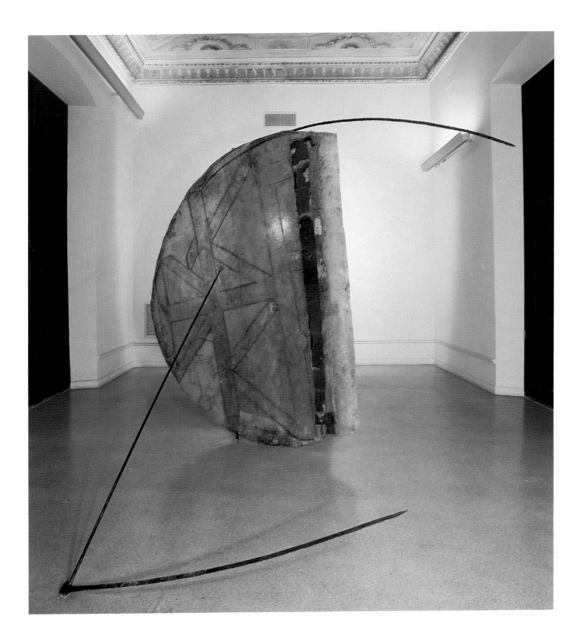

20 *Untitled (Sans titre).* 1984
Polyester resin, plexiglass, carbon fibers and epoxy
resin, 109¼ x 74⅞ x ⅛"
Collection F.R.A.C. Haute-Normandie, Rouen

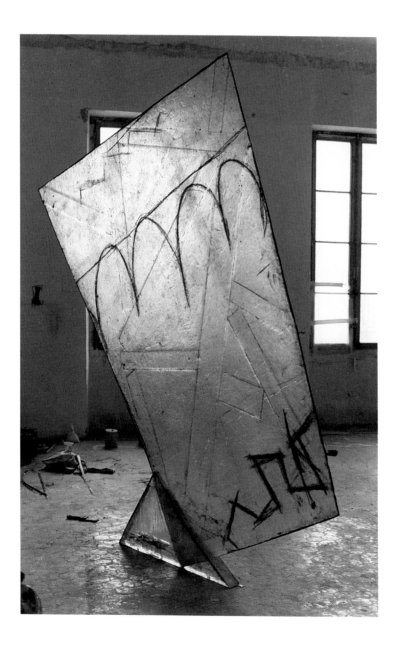

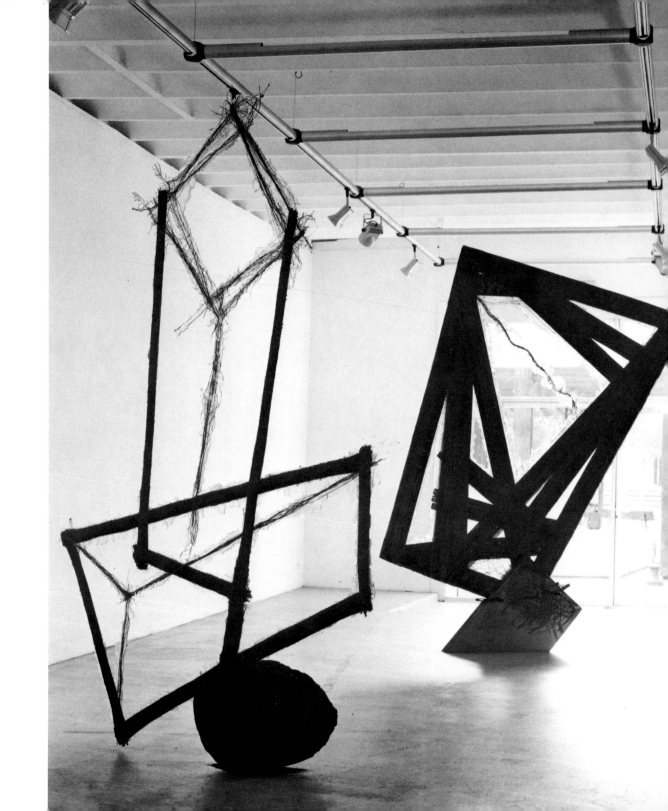

21 a, b *Innumerable* and *Untitled* (*Innombrables* and *Sans titre*). 1984

Innumerable (Innombrables): Epoxy resin, carbon fibers and charcoal, 114⅛ x 82¾ x ⅛″
Courtesy Galerie Farideh Cadot, Paris

Untitled (Sans titre): Epoxy resin, carbon fibers and steel, 114⅛ x 98⅜ x ⅛″
Private Collection

Installation view, A.R.C.A., Marseille, 1985

22 a, b *Cyclops* and *The Other Head of the Family* (*Cyclope* and *L'Autre chef de la famille*). 1984

Cyclops (Cyclope): Epoxy resin, carbon and charcoal, 126 x 102⅜ x 29½″
Collection Musée Cantini, Marseille

The Other Head of the Family (L'Autre chef de la famille): Epoxy resin, carbon fibers and charcoal, 72⁷⁄₁₆ x 70⅞ x ⅛″
Collection F.R.A.C. Languedoc-Roussillon, Montpellier

Installation view, A.R.C.A., Marseille, 1985

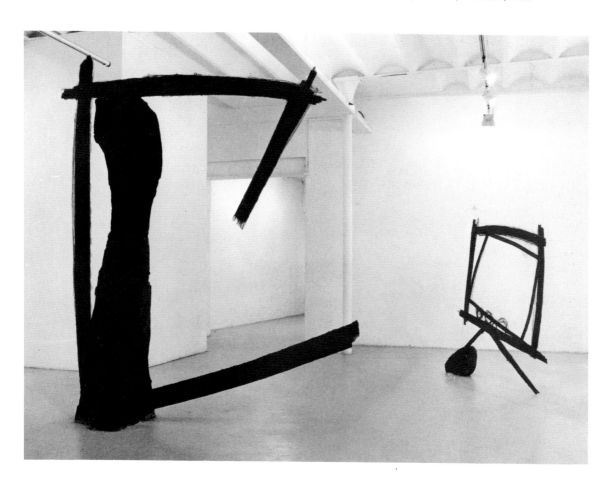

23 *Sculpture.* 1985
 Carbon fibers, resin, fiberglas and stone, 106¼
 x 94½ x ⅛"
 Collection Fonds National d'Art Contemporain, Paris

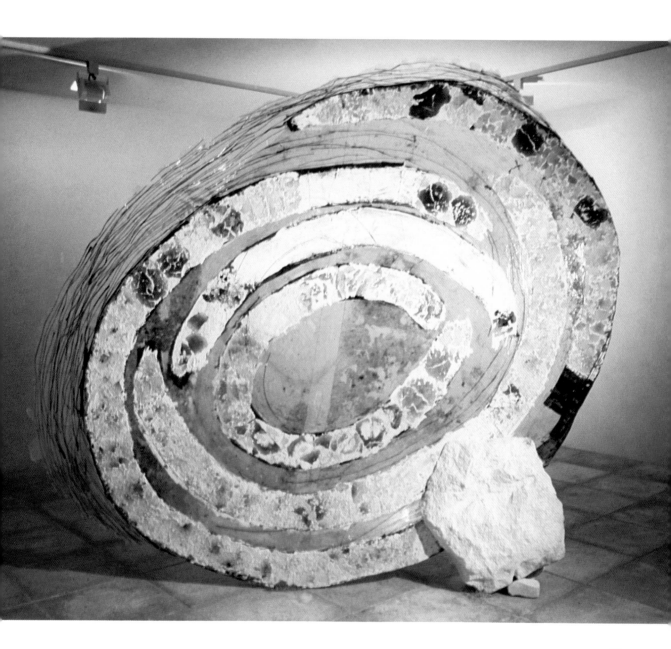

24 *Priestess with Snakes (La Prêtresse aux serpents).*
1985
Fiberglas, epoxy resin, Cassis stone, sandstone,
hemp and plaster, 71 x 109 x ⅜"
Courtesy Gabrielle Bryers Gallery, New York

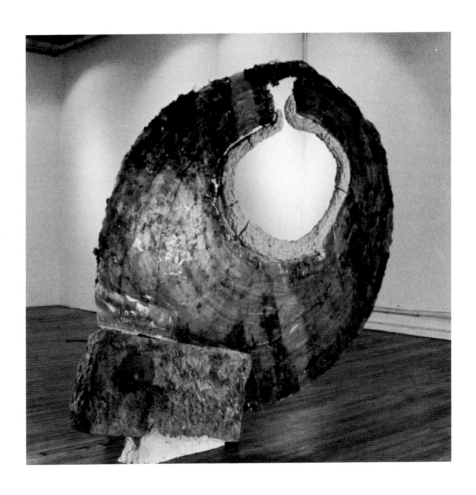

25 a, b *Little Temple* and *Gymnast with Pumice Stone (Petit Temple* and *La Gymnastique à la pierre ponce)*.
1985

Little Temple (Petit Temple): Pastel, fiberglass and carbon fibers, 64 x 68 x ⅛"

Gymnast with Pumice Stone (La Gymnastique à la pierre ponce): Pumice stone, fiberglas, carbon fibers and epoxy resin, 71 x 121 x ⅛"

Courtesy Gabrielle Bryers Gallery, New York
Installation view, Gabrielle Bryers Gallery, New York, 1986

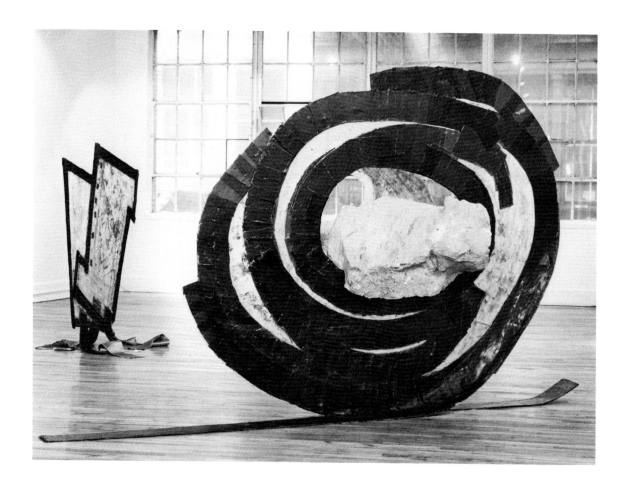

Marie Bourget

Marie Bourget creates visual analogues of words. Her point of departure is the natural world reduced to such basic components as sky, sea, mountains and valleys, as well as simple architectural forms, including houses and churches, that inhabit the landscape. To fabricate these elements the artist reconstructs mental images; in this process the abstract, indeed universal qualities of an idea emerge, rather than its descriptive or pictorial characteristics. The formal purity of these images relies on their minimal shapes, modest materials and spare and symbolic color. Thus, according to Bourget's sensibility, a lake is translated into a rectangle of blue cardboard that floats just above the floor, supported by four hatpins at its corners.

Their extreme simplification and resulting concentration of meaning reduces these images to signs. They become, in a sense, ideographs—codes of representation akin to Chinese characters or Egyptian hieroglyphics. As one critic explains: "What we are dealing with here is neither the designation of a physical object—or its negation, this is (not) a pipe, nor is it the manifestation of a psychological experience, nor expressionism, nor even of a symbolic description. The perceptible information which is *presented* to us—a sheet of paper painted blue—when coupled with the word Lake in its absence of available significant gives rise to an 'objective ideal unity. The latter serves as an intentional correlate of the act of perception' which is neither the signifier of the word nor the perceptible information of the object, 'which does not exist outside the proposition that expresses it.'[1] Thus, the planarity attributed to this thing called Lake could only be pure 'appearance,' a surface effect without depth!"[2]

Most of Bourget's forms are geometric, and each carries more than one association. A crenellated line, for example, suggests both a wavy sea and the roofline of a castle. In a piece entitled *Valley (Vallée)*, Bourget creates a valley by affixing to a wall the two ends of a horizontal length of string, and inflecting it with a triangular-shaped weight suspended at its midpoint. Since the triangle is used elsewhere in the artist's oeuvre to depict mountains, in this piece it represents both mountain and valley. Here, however, their normal geographic relationship is inverted—the mountain sits at the bottom of the valley, and the valley rises above the mountain. A triangle can also represent a steeple or an eave. If we compare *Fabrication of Churches (La Fabrication des églises)* with *Painting of a High Mountain (Peinture de haute montagne)* (cat. nos. 27, 28), we find that the peaked forms of the church steeples echo those of the mountain range. This interplay between works is important to Bourget, who says, "I like to give form; perhaps a succession of forms passing through time which speak of the same things that after all, make our experience evolve."[3] The juxtaposition also demonstrates the undeniable relationships between natural and man-made forms. For example, the mountain peak inspired the church steeple and, historically, both have been romanticized as spiritual images.

As we have seen in *Valley*, Bourget imparts a deeper meaning to her oeuvre through deceptively simple inversions of forms. Similarly, she uses fluctuating viewpoints and perspectives and deliberate reversals of up and down or inside and outside. She causes us to reflect on our own position with regard to the work of art, and with regard to our environment as a whole. As the artist states, "If I place things upside down, it is so that the environment

will surprise me and surprise the viewer. I would like, through my work to lead people to look at things for the first time."[4]

Bourget also uses these strategies to illustrate the perpetual state of flux that characterizes our environment, and the impermanence of nature. She chooses images, such as sky or water, that are inherently mutable. For example, in *Storm (Tempête),* a three-part piece from 1983-84 (cat. nos. 29a-c), both sky and lake are represented by a square of blue cardboard. In the component entitled *Lake (Lac),* the cardboard lies flat on a metal frame which is mounted on four tall legs. Next to it is *Sky (Ciel),* in which the cardboard is placed on the ground, and the base (the frame and legs), although similar in form to that of *Lake,* is partially attached to the wall. This crucial variation in the relative disposition of the elements of the two pieces causes us to wonder what is being represented: are we seeing the sky reflected in the lake, and the lake reflected in the sky? Or has the lake, by virtue of its elevated position, become that which it reflects—the sky— and vice versa? Whereas Bourget's titles often clarify the meanings of her symbols, here they contribute to the state of irresolution. The third element of the work, itself entitled *Storm,* reinforces the transitory nature of *Sky* and *Lake. Storm* is similar to *Lake* in the arrangement of its pieces and in its orientation to the surrounding space, but its profile is more dynamic. The metal frame is tipped and thus creates the impression that the blue square is rocking to one side of its container and that it will eventually slip from it. Ironically, Bourget gives the bases more importance than the almost immaterial blue squares that are ostensibly the subject of the piece —another instance of inversion at work in her art.

Bourget's sculpture has neither volume nor mass; it is graphic, drawn with fine ribbons or strings, or thin lines of iron and steel. And in a curious interplay of painting and sculpture, she often uses empty picture frames as structural elements (see cat. nos. 28, 30a). However, all of these materials are ultimately transcended by the purity of the artist's ideas. The installation space and the element of light are integral to her work. The light source can be contained within the sculpture, as in *Drawing (Dessin)* (cat. no. 26); it can be placed outside the confines of the piece, as in *Eclat*; or its presence can be merely suggested, as in the works that deal with water, fire, reflections or mirrors. In *Eclat,* for example, the circle of light cast by a nearby projector both illuminates the work, allowing us to see the simple tracings of stars created by the strings and pins on the wall, and defines the boundaries of this celestial field. Without the light, the delicate and ephemeral stars might go unnoticed, yet in its presence, these dematerialized orbs appear to be the source of illumination themselves.

Although Bourget's oeuvre is purged of narrative, anecdote and discourse, it is suffused with poetry. Like other artists of her generation who have annexed the domain of Conceptual research, she maintains an emotional quality in her work that breaks stride with the historical antecedents of this idiom. Though her pieces are not physically imposing, they exist in strong rapport with the volumes of the spaces they inhabit. Indeed, because one of Bourget's subjects is balance, it is not surprising that her work exists on the precarious edge between strength and fragility, between density and lightness.

1. Author's note 4, Gilles Deleuze, *Logique du sens*, Paris, 1969, p. 32.

2. *Dispositif fiction*, 1986, p. 12.

3. *Art français: Positions*, 1986, p. 55.

4. Nuridsany, *Art Press*, 1985, p. 36.

Biographical Information

Born in Bourgoin, Isère, October 6, 1952

Lives and works in Paris

Selected Group Exhibitions

Lyon, *Lieux de relation*, March 1980

Galerie Verrière, Lyon, September 1982

Maison de la Culture, Nevers, *Le Paysage en 4 états*, December 1983

Association pour l'Art Contemporain, Nevers, *Pour vivre heureux, vivons cachés*, May 30-June 30, 1984

Le Nouveau Musée, Lyon-Villeurbanne [exhibition untitled], June 23-September 20, 1984. Catalogue with texts by Michel Claura, Bertrand Lavier, Jean-Louis Maubant, Sarkis and Daniel Soutif

36, Avenue du Président Wilson, Paris, *Six Heures avant l'été*, June 20-July 20, 1985

A.R.C., Musée d'Art Moderne de la Ville de Paris, *Dispositif fiction*, December 19, 1985-February 16, 1986. Catalogue with texts by Claude Gintz and Suzanne Pagé

La XLII Biennale di Venezia: Aperto 86. Mensola e Feritoia, June 29-September 28, 1986. Catalogue with text by Suzanne Pagé

Selected One-Woman Exhibitions

Galerie Verrière, Lyon, February-March 1984. Catalogue with text by Michel Nuridsany

Le Coin du Miroir, Le Consortium, Dijon, *La Fabrication d'un Secret*, June-July 1985. Catalogue with text by Eric Colliard

Galerie Claire Burrus, Paris, *Mon Dieu le Tableau Tombe!* September 30-November 12, 1985

Association pour l'Art Contemporain, Nevers, *Plinthe*, May 1986

Galerie Andata Ritorno, Geneva, May 1986

Selected Bibliography

Michel Nuridsany, "Dans la lumière de Marie Bourget," *Art Press*, no. 88, January 1985, p. 36

Alain Coulange, "M. Verjux, M. Bourget et B. Lavier, objets de l'art et objets d'art," *Art Press*, no. 90, March 1985, pp. 34-36

Daniel Soutif, "Fasten Seat Belt: Marie Bourget, embarquement immédiat," *Libération*, July 3, 1985, p. 32

Michel Nuridsany, "Dans la lumière de Marie Bourget," *Le Figaro*, July 8, 1985, p. 27

Knarf Lessour, *Plus 2*, January 1986, p. 27

Françoise Woimant, "Estampes en marge." *Nouvelles de l'Estampe*, no. 85, March 1986, pp. 24-26

Olivier Lugon, "Le Paysage comme vue de l'esprit," *Le Courrier de Genève*, May 10, 1986, p. 16

Didier Semin, "Un Certain art français: Quand les formes deviennent attitude," *Art Press*, no. 104, June 1986

26 *Drawing (Dessin).* 1985
Painted iron and light bulb, 86⅝ x 29½ x 17⅛″
Courtesy Galerie Claire Burrus, Paris

27 *Fabrication of Churches (La Fabrication des églises).* 1984
Painted iron, 69¾ x 120⅛ x 11⅜″
Collection F.R.A.C. Rhône-Alpes, Lyon

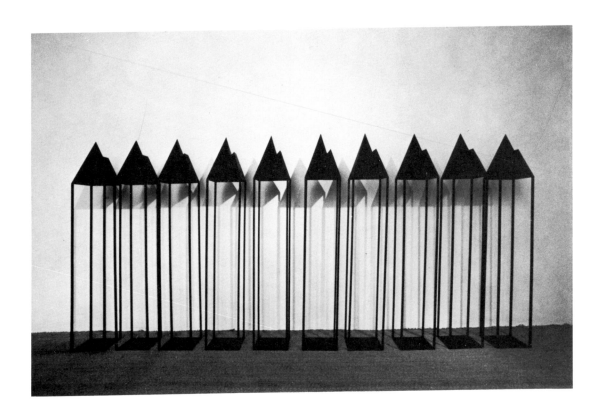

28 *Painting of a High Mountain (Peinture de haute montagne).* 1985
Iron, string, wood frames and glass, 137¾ x 232¼ x 4"
Courtesy Galerie Claire Burrus, Paris

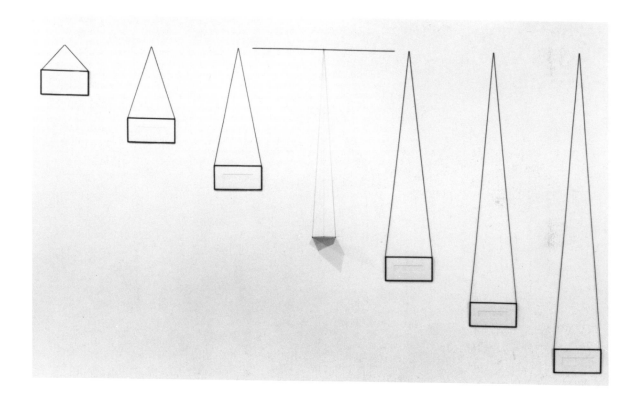

29 a-c *Storm (Storm, Lake* and *Sky) (Tempête [Tempête,*
Lac and *Ciel]).* 1983-84

Storm (Tempête). 1983-84: Iron and cardboard, 45½
x 33¾ x 6″

Collection F.R.A.C. de Bourgogne, Dijon

Lake (Lac). 1984: Iron and cardboard, 45½ x 20½
x 20½″

Private Collection

Sky (Ciel). 1984: Iron and cardboard, 45½ x 53¼ x 6″

Private Collection

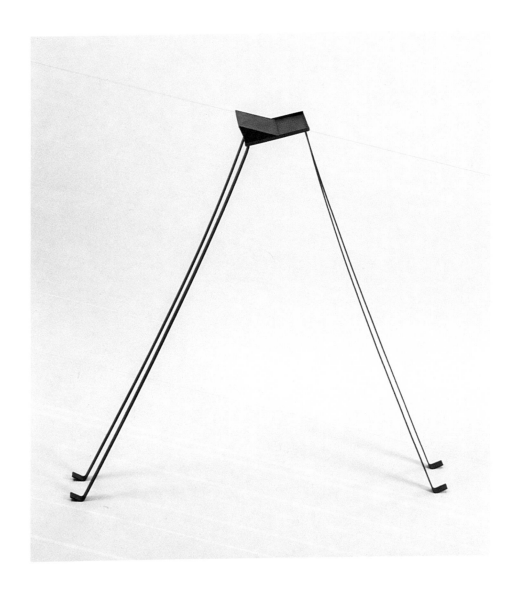

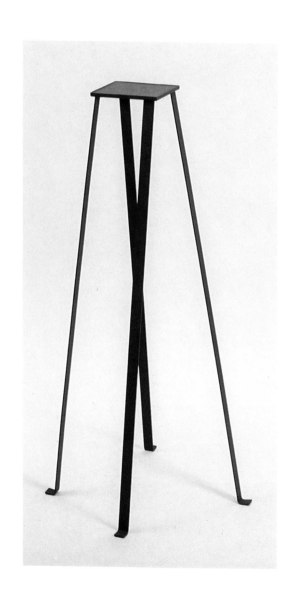

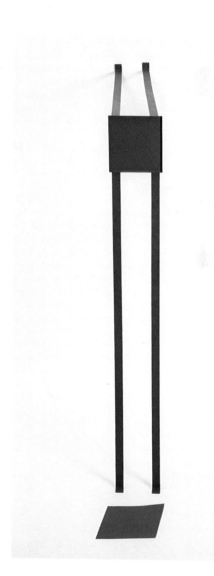

30 a, b *Skimming the Water* and *Sky (A Fleur d'eau* and *Ciel).*
1985
Skimming the Water (A Fleur d'eau) (foreground):
Wood frames and glass, two pieces, 46⅞ x 9⅞"
Collection of the artist
Sky (Ciel) (background): Painted iron, 85 x 9¾ x 5¼"
Collection F.R.A.C. Ile-de-France, Paris
Installation view, Galerie Claire Burrus, Paris, 1985

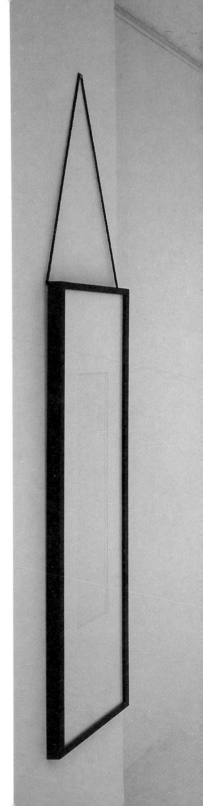

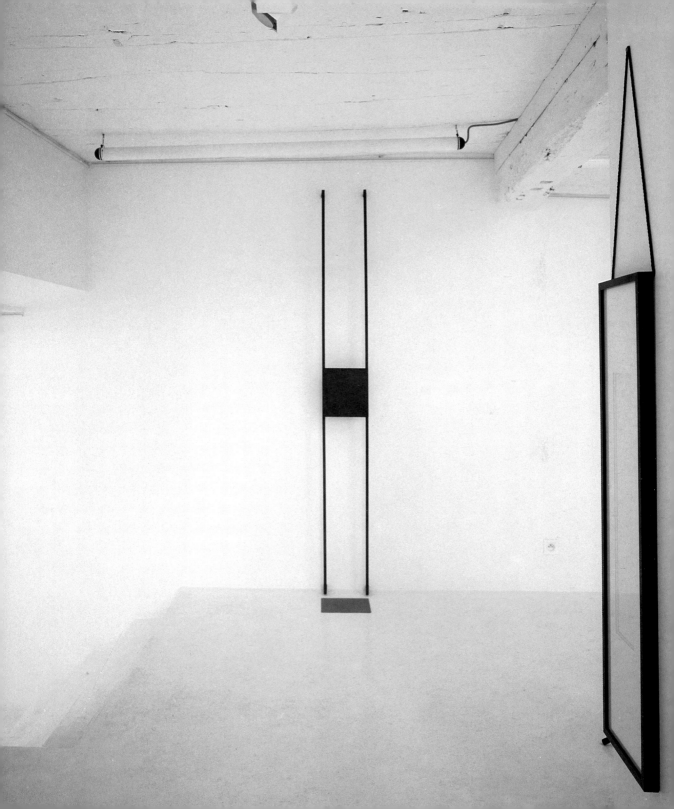

31 *Complaint (Plainte)*. 1985
Iron and cord, 118 x 73⅞ x 4″
Private Collection, Paris

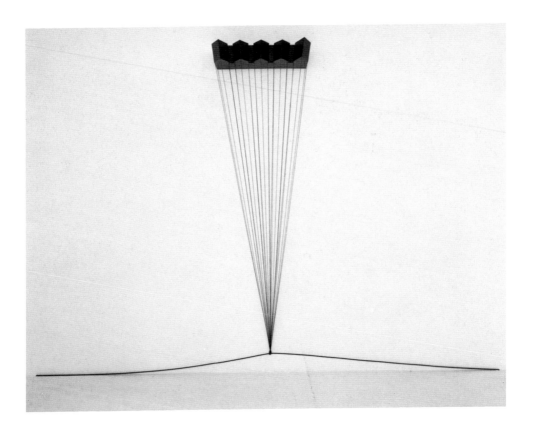

32 *Visualizing Time (Visualiser le temps)* (detail). 1986
String, wood and pastel, 236¼ x 118"
Association pour l'Art Contemporain, Nevers

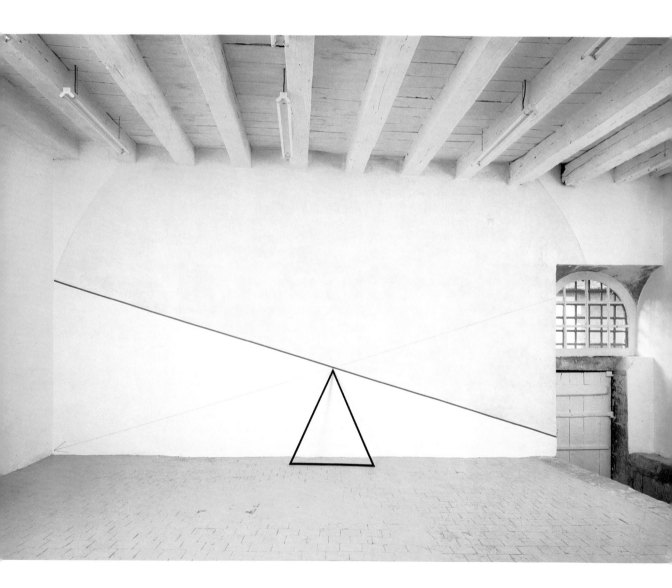

Bernard Faucon

Bernard Faucon remembers asking his mother's doctor for a potion that would keep him from growing up.[1] His preoccupation with childhood, a childhood that is at once real, lost and imagined, inhabits his earliest series of photographs. As the artist explains, "I nourish my images with a childhood experience to which I always return: each time I set out to think of an image, I refer to a primal experience. For me, this is a guarantee of authenticity."[2]

To represent these memories, Faucon composes tableaux vivants and photographs them. The protagonists of these staged dramas are mannequins of young boys, elaborately made-up, coiffed and dressed by the artist in Bermuda shorts, sailor suits and the like. They act out scenes which are sometimes straightforward—two boys staring through a telescope at a solitary star in the blackened sky, for example—but which more often are not. Frequently, the mundane nature of the narratives is subverted by inexplicable elements—apparitions of balls of fire, pieces of paper or even children flying through the air. What pass at first as the innocent and bucolic pastimes of adolescents are tainted by strange interventions and elemental occurrences which transform scenes of everyday life into mystical rituals. These are not simply memories of childhood, we realize. Yet their messages remain obscure.

The use of mannequins serves to heighten the ambiguity of the situations. In their stilted postures and realistic makeup they are at the same time lifeless and alive. Static and made of plastic, the figures are arranged in poses of action; yet by being photographed they are petrified once again. Photographing them doubles their immobility, but at the same time gives them life. Their smiling faces and vacant stares reveal nothing of the dilemmas in which they are caught. As one critic observes, "More insidious still, the euphoric expressions fixed to these wax faces are quite perpetual, completely independent of the actions the mannequins are performing. What can be more disturbing than an expression which denies the laws of expression, whose immutability denies the correspondence between the internal and the external, between cause and effect?"[3] Faucon further confounds the notions of the real and the artificial by sometimes posing a living boy among the mannequins. This person is often indiscernible at first, demonstrating how close the real and the artificial are to each other and, consequently, discrediting the real.

Faucon's photographs are printed by the Atelier Fresson according to a four-color carbon process invented in Paris around the turn of the century by Théodore-Henri Fresson and carried on today by his grandson. This process produces qualities that are perfectly suited to Faucon's images. Both the colors and the delineation of form are muted, subtle, grainy and soft; they bypass harsh reality to enhance the effect of revery. At times, the delicacy of the colors seems closer in spirit to the pale washes of watercolor than to the mechanical process by which they are achieved. The particular moods of these works are also heightened by the lighting, which is always artificial, even when the scenes are photographed outdoors in the artist's native Provence. The golden light seems to emanate from within the figures or objects themselves. It is so pervasive as to blur contours rather than to throw harsh shadows, and it is at once mellow and mystical.

One of the few constants in Faucon's oeuvre is

the summer landscape of southern France. Gradually the "human presence"—that is, the mannequins—has disappeared, and from 1983 forward the inanimate objects, natural phenomena or even the landscapes themselves have become the subjects of Faucon's work. Often, in earlier scenes, fire erupted amid groups of children at play; it assumes center stage in more recent works, for example *The Room of Fire (La Chambre qui brûle)* (cat. no. 34), in which a fire of mysterious origin engulfs but does not burn the centrally placed table. In images such as these, the impenetrable riddles of the mannequin photographs prevail: logic is not the foundation on which they are built. The persistence of fire in Faucon's oeuvre recalls René Magritte's painting, in which fire also plays an important role. Indeed, the mysterious circumstances and inexplicable elements that flood Faucon's photographs, as well as his exploitation of fantasy, dreams and recollections suggest inspiration in a Surrealist heritage.

Ultimately, the romantic landscape itself becomes the subject of these pictures. Faucon explains, "I do not crop the landscape. I seek to absorb the vastest landscape possible, to define a world. The composition must be liveable, precise, but always rather precarious When everything works out, the scene comes to life. Not theatrically so, but like the life of an image whose apotheosis comes with the click of a shutter. Immediately after, I destroy, I tidy up, I remove all traces. I close my box of tricks, there is no going back."[4]

Faucon's most recent series is entitled *Rooms of Love (Les Chambres d'amour)* (see cat. nos. 36-38). What these rooms project, above all, is an aura. In some, the aftermath of lovemaking is implied by the rumpled sheets or partially revealed human torsos in sleeping positions. In others, the effect is more mysterious, as in the haunting apparition of faces on a floor. And sometimes the structure of the room itself is the subject of the work, yet here the walls are transformed by delicate traceries of color and drawing, and the floors are blanketed by burning embers, freshly fallen snow or dense, tall grass (see cat. nos. 36, 38). In all, the spaces are silent; narration is only suggested, and the imagery is more reductive than in the earlier works. The romance of light and color alone creates the poetic expression. As one critic has said, Faucon's intention is ". . . to pursue the real and, by means of artifice, extract from it a bit of immateriality, a bit of the beyond."[5]

1. *Summer Camp*, 1980, unpaginated.
2. Guibert, *Le Monde*, 1981, p. 15.
3. Barthes, *Zoom*, 1979, p. 53.
4. *Summer Camp*.
5. Michelena, *Bernard Faucon: Le Part du calcul*, 1985, p. 12.

Biographical Information

Born in Apt, Provence, September 12, 1950
La Sorbonne, Paris, 1969-74, Maîtrise (Philosophy)
Painter, 1966-76
Photographer, 1976-present
Lives and works in Paris and Provence

Selected Group Exhibitions

Santa Barbara Museum of Art, California, *Invented Images*, February 20-March 23, 1980. Catalogue with texts by Steven Cartwright and Phyllis Plous. Traveled to Portland Art Museum, Oregon, April 8-

May 18; Mary Porter Sesnon Art Gallery, Santa Cruz, California, May 28-June 21

Musée d'Art Moderne de la Ville de Paris, *XI Biennale de Paris*, September 22-November 2, 1980. Catalogue

Everson Museum of Art, Syracuse, New York, *The New Color: A Decade of Color Photography*, May 15-July 26, 1981. Catalogue with text by Sally Eauclaire. Traveled in United States and Canada, 1981-82

The Friends of Photography Gallery, Sunset Center, Carmel, California, *4 French Photographers*, November 6-December 6, 1981

Musée National d'Art Moderne, Centre Georges Pompidou, Paris, *In Situ: Douze Artistes pour les galeries contemporaines*, March 25-May 31, 1982. Catalogue with texts by Bernard Bazile, Jacques Beauffet, Dominique Bozo, Louis Deledicq, Maurice Eschapasse, Bernard Lamarche-Vadel, Louis Marin, Katherine Schmidt and the artist

Corcoran Gallery of Art, Washington, D.C., *Color as Form: A History of Color Photography*, April 10-June 6, 1982. Catalogue. Traveled to International Museum of Photography at George Eastman House, Rochester, New York (organizer), July 2-September 5

Lijnbaancentrum, Rotterdamse Kunststichting, *Staged Photo Events*, September 3-October 3, 1982. Catalogue

San Francisco Museum of Modern Art, *Recent Color*, September 3-November 7, 1982. Catalogue

Musée d'Art Moderne de la Ville de Paris, *Photographie France aujourd'hui*, 1982. Catalogue

Association Tours-Art Vivant, *France-Tours, art actuel: Première Biennale d'art contemporain*, Centre de Création Contemporaine, Tours, April 22-May 29, 1983. Catalogue with texts by Jean-Christophe Ammann, Marie-Claude Beaud, Michel Giroud, Giovanni Joppolo, Alain-Julien Laferrière, Bernard Lamarche-Vadel and Jean de Loisy

Espace Niçois d'Art et de Culture, Nice, *Peindre et photographier*, July 7-September 30, 1983. Cata-logue with texts by Claude Fournet and Philippe Mezescaze

San Francisco Museum of Modern Art, *Facets of the Collection: Recent Acquisitions*, September 16-November 27, 1983

Fundación San Temo, Buenos Aires, *Maestros de la Fotografia Francesa del Siglo XX*, 1983. Catalogue

Musée National d'Art Moderne, Centre Georges Pompidou, Paris, *Images fabriquées*, February 10-March 13, 1983. Catalogue. Traveled to Musée des Beaux-Arts, Nantes, November 4-December 23; Musée d'Art Actuel, Hasselt, Belgium, June 8-July 8, 1984

Leo Castelli Gallery, New York, *Drawings/Photographs*, June 8-September 30, 1983

Visual Arts Museum, School of Visual Arts, New York, *New Images in Photography*, March 5-24, 1984

Fisher Art Gallery, University of Southern California, Los Angeles, *French Spirit Today*, March 19-April 21, 1984. Catalogue with texts by Jean-Louis Froment and Catherine Strasser. Traveled to Museum of Contemporary Art, La Jolla, California, June 16-August 3

F.R.A.C. Champagne-Ardenne, Epernay (organizer), *Images imaginées*, Musée Rimbaud, Charleville-Mézières, June 15-July 28, 1984; Cherbourg, August 11-September 15; Niigata B.S.N. Art Museum, Japan, November 1984. Catalogue

Le Nouveau Musée, Lyon-Villeurbanne [exhibition untitled], June 22-September 20, 1984. Catalogue with texts by Michel Claura, Bertrand Lavier, Jean-Louis Maubant, Sarkis and Daniel Soutif

Hirshhorn Museum and Sculpture Garden, Smithsonian Institution, Washington, D.C., *Content: A Contemporary Focus, 1974-1984*, October 4, 1984-January 6, 1985. Catalogue with texts by Howard N. Fox, Miranda McClintic and Phyllis Rosenzweig

Fukuo Art Museum, Japan, *Contemporary Photography: Towards New Development*, 1984. Catalogue

Forum Stadtpark, Graz, *Symposium über Fotografie*, 1984. Catalogue

Metz pour la Photographie (organizer), *Construire les paysages de la photographie: 21 Auteurs & plasticiens contemporains*, Caves Sainte-Croix, Metz, 1984. Catalogue with texts by Jean-François Chevrier, Michele Chomette, Jean-Marc Poinsot and the artists. Traveled in France

Musée des Arts Décoratifs, Paris, *Sur invitation*, 1984. Catalogue

Galerie du Musée de la Photographie, Charleroi, *Photographie ouverte*, 1985. Catalogue

Tsukuba Museum of Photography, Japan, *Paris, New York, Tokyo*, 1985. Catalogue

Junta de Comunidades de Castilla-La Mancha, Guadalajara, Spain, *Semana internacional de la fotografia*, 1985. Catalogue

White Columns, New York, *Signs of the Real,* March 4-29, 1986. Catalogue with text by Deborah Bershad

A.F.A.A. (Association Française d'Action Artistique), Paris (organizer), *Constructions et fictions*, Fondazione Scientifica, Querini-Stampalia, Venice, June 20-July 30, 1986; Institut Français, Naples, October 1-30. Catalogue with text by Régis Durand

Selected One-Man Exhibitions

Galerie Lop-Lop, Paris, April 28-May 28, 1977

Galerie-Librairie La Quotidienne, Aix-en-Provence, 1977

Galeria Fotomania, Barcelona, May 30-June 26, 1978

Galerie Agathe Gaillard, Paris, April 4-May 26, 1979; 1984; *Les Chambres d'amour*, June-July 1986

Castelli Graphics, New York, November 10-December 1, 1979; September 19-October 10, 1981; January 8-29, 1983; *The Rooms of Love*, May 2-24, 1986

Galerie Canon, Geneva, December 9, 1979-January 3, 1980

Kunstcentrum 't Venster, Rotterdam, December 9, 1979-January 21, 1980

Galerie Napalm, Saint Etienne, April 9-May 18, 1981

Galerie Junod, Lausanne, November 17-December 24, 1981; 1983

Galerie Paula Pia, Antwerp, February 2-March 2, 1982

Musée de Toulon, *Bernard Faucon*, December 2, 1982-January 9, 1983. Catalogue with text by Marie-Claude Beaud

Zeit-Photo-Salon, Tokyo, December 13-28, 1982

Galerie Fiolet, Amsterdam, 1983; November 1986

Galerie Imagique, Saint Saturin d'Apt, 1983

Galerie Axe Actuel, Toulouse, February 5-March 11, 1985

Houston Center for Photography, Texas, February 28-April 6, 1985

Galerie Images Nouvelles, Bordeaux, *La Part du calcul dans la grâce*, April 1985; December 1986

Galerie Artem, Quimper, 1985

Galeria Modulo, Lisbon, 1985

Galerie de Prêt, Angers, 1985

Galerie Alexandre de la Salle, Saint Paul-de-Vence, 1985

Musée Nicephore Nièpce, Chalon-sur-Saône, 1985

Van Reekum Museum, Apeldoorn, The Netherlands, 1985

Galerie Jade, Colmar, April-May 1986

Musée d'Auriac, May-June 1986

Centre d'Art Contemporain, Forcalquier, July-August 1986

Musée de la Charité, Marseille, October 15-December 31, 1986. Catalogue

Galerie Fiolet, Amsterdam, November 1986

Selected Bibliography

By the Artist

Summer Camp, New York, 1980. French edition, *Les Grandes Vacances*, Paris, 1981

"Les Créateurs," *Autrement*, no. 48, 1983

Mois de la photo, Paris, 1984

Evolution probable du temps, Paris, 1986

Les Papiers qui volent, Paris and Tokyo, 1986

On the Artist

Hervé Guibert, "Bernard Faucon chez Agathe Gaillard: Les Plaisirs de l'enfance," *Le Monde*, April 5, 1979, p. 19

Christian Caujolle, "Les Chromos d'enfance de Bernard Faucon," *Libération*, April 5, 1979, pp. 14-15

Michel Nuridsany, "Faucon: L'Enfance rêvée," *Le Figaro*, April 10, 1979, p. 26

André Laude, "Bernard Faucon: Chez Agathe Gaillard," *Les Nouvelles Littéraires*, no. 2684, April 26-May 3, 1979, p. 28

Pierre Jouvet, "Faux Vrais," *Le Cinématographe*, no. 49, July 1979

Roland Barthes, "Bernard Faucon," *Zoom*, no. 57, 1979, pp. 46-53

Madelaine Burnside, "Bernard Faucon," *Arts Magazine*, vol. 54, February 1980, p. 44

Anthony Bannon, "Photographers' Trickery Shows Camera Can Lie," *Buffalo Evening News*, April 17, 1980

Janet Kutner, "Show's Photos Develop into Art," *The Dallas Morning News*, July 4, 1980, p. C10

Luc Pinhas, "Bernard Faucon, la force du dévoilement," *Masques*, no. 7, Winter 1980-81, pp. 116-119

Hervé Guibert, "Un Entretien avec Bernard Faucon," *Le Monde*, January 14, 1981, p. 15

Jean-Pierre Thibaudat, "Bernard Faucon: Le Comble de la photographie," *Libération*, January 24, 1981, p. 16

Michel Tournier, "Chant d'amour pour les petits mannequins," *L'Express*, January 31-February 6, 1981, pp. 108-109

Kineo Kuwabala, "Bernard Faucon," *Asahi Camera*, October 1981

Sally Eauclaire, *The New Color Photography*, New York, 1981

Photography Year 1981, Alexandria, Virginia, 1981, pp. 12-14

Donna-Lee Phillips, "Recent Color: The Contemporary Concern," *Artweek*, vol. 13, September 25, 1982, pp. 1, 16

Nicolas A. Moufarrege, "Bernard Faucon: Summer Camp," *Arts Magazine*, vol. 57, October 1982, p. 5

Christian Caujolle, "L'Enigme du papillon dans la Cène de Bernard Faucon," *Anthologie de la Critique 82*, Paris, 1982

Christian Caujolle, "Bernard Faucon," *Photomagazine*, no. 37, February 1983, pp. 58-66

"Daniel Tremblay, Bernard Faucon, Musée de Toulon," *Art Press*, no. 67, February 1983, p. 49

Dominique Carré, "L'Enfance réinventée: Bernard Faucon," *Beaux-Arts Magazine*, no. 4, July-August 1983, pp. 78-79

Alain Bergala, "Le Vraix, le faux, le factice," *Les Cahiers du Cinéma*, no. 351, September 1983, pp. 4-9

"Figurative Contexts at Turman Gallery," *Arts Insight*, vol. 5, September 1983

Eileen Jensen, "New Trends in Photography Examined," *Arts Insight*, vol. 5, October 1983

Michel Nuridsany, "L'Univers rêvé de Bernard Faucon," *Art Press*, no. 84, September 1984, p. 25

Hervé Guibert, "Faucon l'inspiré," *Le Monde*, November 13, 1984, p. 15

Christian Caujolle, "Photographie, Bernard Faucon," *Beaux-Arts Magazine*, no. 18, November 1984, pp. 58-61

Philippe Mezescave, "Bernard Faucon: Un Oiseau

fort," *Masques*, no. 21, Spring 1984, pp. 166-169

Allen Ellenzweig, "Bernard Faucon at Gallery Agathe Gaillard," *Art in America*, vol. 73, May 1985, p. 183

Dave Crossley and Lynn McLanahan, "Paris in the Fall," *Spot*, Spring 1985, p. 7

Lynn McLanahan, "Bernard Faucon: Growing Up," *Spot*, Spring 1985, pp. 8-9

Hervé Guibert, "Comment fabriquer une étoile," *L'Autre Journal*, nos. 8 and 10, 1985

Christian Caujolle, *Clichés*, no. 13, 1985

Jean-Michel Michelena, *Bernard Faucon: La Part du calcul dans la grâce*, Bordeaux, 1985

Alexandra Anderson, "What's Hot at Foto Fest," *American Photographer*, March 1986, p. 16

33 *The Broken Glass (Le Verre cassé).* 1979
 Fresson color photograph, 12 x 12″
 Courtesy Castelli Graphics, New York

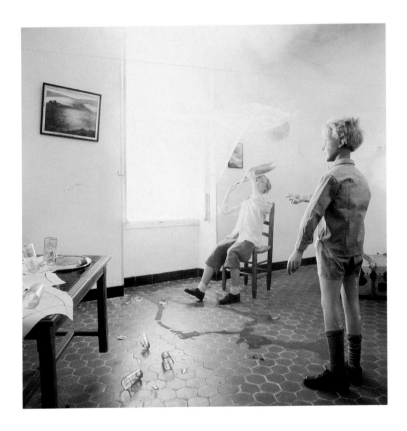

34 *The Room of Fire (La Chambre qui brûle)*. 1981
 Fresson color photograph, 12 x 12"
 Courtesy Castelli Graphics, New York

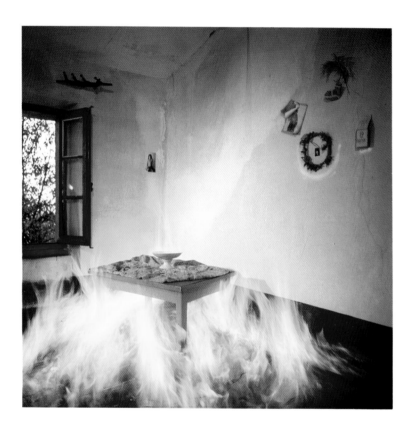

35 *The Eternal Life (La Vie éternelle).* 1984
 Fresson color photograph, 12 x 12″
 Courtesy Castelli Graphics, New York

36 *The Embers (The Ninth Room) (Les Braises [la
neuvième chambre]).* 1985
Fresson color photograph, 12 x 12″
Courtesy Castelli Graphics, New York

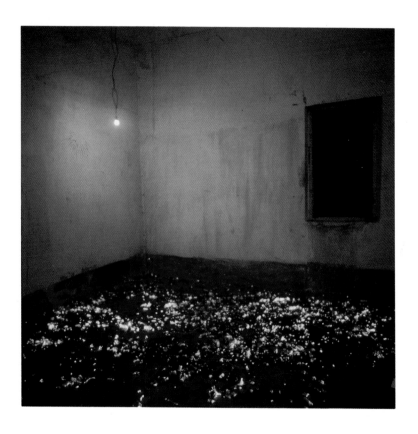

37 *The Stained Glass (The Thirteenth Room) (Le Vitrail*
[la treizième chambre]). 1985
Fresson color photograph, 12 x 12″
Courtesy Castelli Graphics, New York

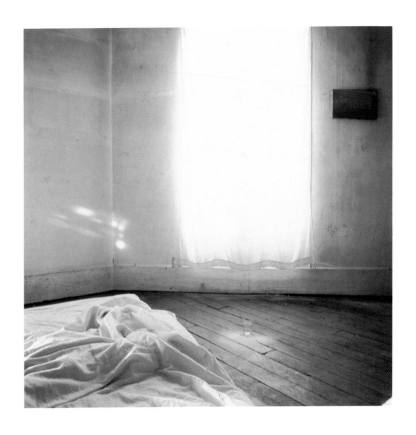

38 *The Snowstorm (The Fourteenth Room) (La Tem-
pête de neige [la quatorzième chambre])*. 1985
Fresson color photograph, 12 x 12"
Courtesy Castelli Graphics, New York

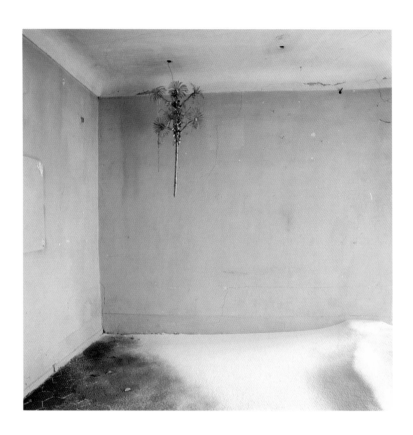

Philippe Favier

Philippe Favier's paintings exist at the limits of visibility. In passing, one might mistake them for spots or stains on the wall. Yet if one's curiosity is piqued enough to make one approach closely, the intimacy and magic of his microcosmic world is revealed.

Although their scale rarely exceeds a few inches, Favier's paintings on paper or glass engage the walls they occupy and thus take on greater dimensions. So crucial is this relationship with the wall that the works are perhaps more accurately defined as installations than as paintings. Despite their miniscule format, they are demanding—whereas the totality of large-scale works can at times be absorbed in a passing glance, Favier's paintings require the viewer to take the time to approach and focus on their minute detail. These poetic images reveal themselves only if one pays attention.

There are three stages in Favier's creative process: first, he paints his images on paper, sometimes building up the pigment to form a relief-like surface, then he meticulously cuts out the elements with a razor and, finally, he arranges them (with glue or pins) on the wall. This third, compositional step is the most important one because in the juxtaposition of the lilliputian figures and their accoutrements, not only does the narration develop, but also a sense of space and depth is created, involving the whiteness of the blank wall. Perspective is rendered by decreasing the size of the figures, causing them to appear to recede even though they exist with the larger figures on a single plane, the wall. The painted elements thus serve only as reference points for the total composition, leaving the viewer to mentally "connect the dots."

Not only is the interrelationship of parts significant, but also the overall silhouette of each painting maintains a wholly independent function. From afar, these contours suggest a lively calligraphy, a lyrical play of spirals, arabesques and other abstract patterns. Often, however, these silhouettes reinforce the subjects of the works. For example, in IRIS (cat. no. 39) the colony of pitched tents, beach umbrellas and sunbathers suggests in its formation the receding curve of the shoreline. Favier's earliest themes involved military combat—the arrangements resembled deployments of toy soldiers—and he sought to impart to them an epic quality reminiscent of nineteenth-century history painting. The incongruity between the monumentality of the subject matter and the diminutiveness of the scale in which it is portrayed sets up an ironic tension that defies a mere anecdotal reading of these motifs.

The reference in Favier's works to epic poetry is intentional, and for him structure and meaning in writing are analogous to those same elements in painting. For example, when asked why he works on such a small scale, he replied, "It is small because I want to come as close as possible to handwriting, to the writer's gesture, to the minimum gesture."[1] As one critic noted, "To be exact, it is not a question of painting, but rather of plastic poems: figures become crowds, and crowds landscapes (the curve of a beach, the sinuosity of a road), a little like Apollinaire's calligrams, where the disposition of the type reinforces the meaning of the poetic text."[2]

In 1982-83 Favier painted a series of harem scenes replete with all the trappings—fountains, palm trees, Persian carpets, decorative arches and columns, luscious fruits and erotic couplings (see cat. no. 40). In peering at these paintings from close

range, the spectator is unwittingly cast in the role of voyeur to these amorous acts. The marvelous intricacy, rhythmic line, decorative quality and small scale of the works recall the ornamental tradition of Islamic art—specifically Persian miniature painting. Iconographically and stylistically, medieval manuscript illumination is also evoked, and some works also display a kind of fantasy akin to that of medieval bestiaries.

Favier's subjects have continued to develop in a more humorous and fanciful vein. His imagination seems boundless, particularly in the series in which giant fruits and vegetables—watermelons, bananas, cabbages, pickles and peppers—are feverishly agitated in combat with human figures. In *Leeks in French Dressing (Et l'espoir, O vaine aigrette)*, for example, a squadron of giant leeks is attacked by a troop of chefs wearing the traditional white caps and wielding their cooking utensils as weapons. Yet there is also a dark side to Favier's humor that populates his universe with skeletons, hanged men and figures engaged in macabre dances of death.

In 1985 the artist changed his medium from paper to glass, using irregularly shaped fragments similar to those in the lead tracery of medieval stained-glass windows (see cat. nos. 44-48). Favier exploits the transparency of glass, painting it on both sides and applying a predominantly black ground on the verso, which is then partly scratched away with a needle and painted in jewel-like colors. Whereas the brilliance of stained glass is created by light shining through the glass, in these paintings it is achieved by the vibrant patches of color that rise from the somber background. The glass paintings are not as microscopic in scale as the paper pieces, yet the miraculously fine rendering of drawn detail is un-

paralleled in his earlier work. The same thematic mélange of humor, drama, sex and violence inhabits the glass pieces, though it is joined by more familiar still-life objects that seem to belong to the intimate autobiography of the artist. The glass fragments, each of which is an individual work, are dispersed randomly in constellations on the wall; as such, they glitter like stars.

Recently, Favier has also produced a wonderfully inventive series of etchings using the lids of preserved food-tins as his plates (see cat. nos. 42, 43). Here again he gives free rein to his imagination, letting the labels, shapes and origins of the tins suggest the images. In *Imported from Spain (Importé d'Espagne)* (cat. no. 43), for example, he uses a circular lid stamped with those words to create a bullfight scene, complete with bull, toreador and sombreroed spectators. The precision of his draftsmanship and the delicate tonal modulations in these prints are characteristically his own.

Favier's oeuvre is, in one sense, deceptive. The simplification that we would expect from working on such a small scale results instead in an increased complexity. Similarly, his miniature format cloaks a much grander ambition—to endow these works with power that far exceeds their actual size.

1. Nuther, *Halle Sud*, 1985, p. 2.
2. Champey, *Art Press*, 1982, p. 12.

Biographical Information
Born in Saint Etienne, June 21, 1957
Ecole des Beaux-Arts de Saint Etienne, 1979-83
Artist in Residence, Villa Medici, Rome, 1985-86
Lives and works in Saint Etienne

Selected Group Exhibitions

Galerie Attitude, Strasbourg, *Napalm chez Attitude*, June 1981

Galerie N.R.A., Paris, *Cent Peintres de petit format*, October-November 1981

A.R.C., Musée d'Art Moderne de la Ville de Paris, *Ateliers 81/82*, November 26, 1981-January 3, 1982. Catalogue with texts by Suzanne Pagé and Didier Semin

Galerie d'Art Contemporain des Musées de Nice, *L'Air du temps: Aspects de la Figuration Libre en France*, February 27-April 11, 1982. Catalogue with texts by Xavier Girard, Otto Hahn and Marc Sanchez

Le Nouveau Musée, Lyon-Villeurbanne, *Proposition 2*, April 1982

Art Prospect, Paris (organizer), *Réseau art*, posters and billboards commissioned for public display in France, June 1-15, 1982. Catalogue with texts by Jean-Louis Connan and Alain Garo

Kunsthalle Nurnberg, *Meister der Zeichnung*, June 1982. Catalogue with text by Maurice Eschapasse. Traveled to Kunstmuseum Basel, December 1982

Musée de Toulon, *Quatre Ans d'acquisitions*, July 1982. Catalogue

A.R.C., Musée d'Art Moderne de la Ville de Paris, *XII Biennale de Paris*, October 1982. Catalogue with texts by Jacques Louis Binet, Dany Bloch, Catherine Francblin, Monique Kissel, Carole Naggar and Jean-Marie Poinsot. Traveled in part to Sara Hildenin Taidemuseo, Tampere, Finland, January 1983; Kunstnernes Hus, Oslo, March

Espace Lyonnais d'Art Contemporain, Lyon, *Figures Imposées*, January 25-March 15, 1983. Catalogue with texts by Bernard Ceysson, Xavier Girard, Herve Perdriolle and Didier Semin

Pavillon des Arts, Paris, *Une Journée à la campagne*, June 9-August 28, 1983. Catalogue

A.F.A.A. (Association Française d'Action Artistique), Paris (organizer), *Arte Francés Contemporaneo*, Museo Sivori, Buenos Aires, July 13-August 3, 1983; Museo Nacional de las Artes Plásticas y Visuales, Montevideo, August 10-September 4; Museo del Banco Central, Lima, September 24-October 20; Casa de la Cultura, La Paz, November

Neue Galerie am Landesmuseum Joanneum, Graz, *Eros mythos ironie*, September 1983. Catalogue

Association "C'est rien de le dire," Rennes, *La Douceur de l'avant-garde*, 1983. Catalogue

Centre National des Arts Plastiques, Paris (organizer), *Acquisitions F.R.A.C. Rhône-Alpes 1983 (La Jeune Figuration actuelle)*, February 28-March 21, 1984. Catalogue

Fisher Art Gallery, University of Southern California, Los Angeles, *French Spirit Today*, March 19-April 21, 1984. Catalogue with texts by Jean-Louis Froment and Catherine Strasser. Traveled to Museum of Contemporary Art, La Jolla, California, June 16-August 3

Galerie C. le Chanjour, Nice, March-April 1984

Musée Cantonal des Beaux-Arts, Lausanne, *Rite rock rêve: Jeune Peinture française*, May-June 1984. Catalogue with texts by Marie-Claude Beaud and Erika Billeter. Traveled to Heidelberger Kunstverein, June-July; Kunsthaus Aarau; Sonja Henies and Neils Onstads Foundation, Hovikodden, Norway; Nordjyllands Kunstmuseum, Aalborg, Denmark

La Biennale di Venezia: Peinture en France, May 20-September 16, 1984. Catalogue with texts by Daniel Abadie et al.

Musée de Brou, Bourg-en-Bresse, *La Peinture refigurée*, June 28-September 2, 1984

Chapelle de la Salpétrière, Paris, *36 Artistes pour médecins sans frontières*, January 14-February 17, 1985

Centre Culturel de Boulogne-Billancourt, Paris, *Les Mille et une nuits*, January 25-March 17, 1985

A.F.A.A. (Association Française d'Action Artistique), Paris (organizer), *Exposition d'art français contemporain: Douze Artistes français dans*

l'espace, Seibu Museum of Art, Tokyo, May 20-June 23, 1985; O'Hara Museum, Kurachiki, July 12-August 4

Zagreb Museum, *French Painting 1960-1980*, May 1985

Centre d'Art de Flaine, *Le Frac Rhône-Alpes à Flaine*, February 1985

Ecole Régionale des Beaux-Arts, Saint Etienne, *Combas, Favier, Laget, Traquandi*, May 1985. Catalogue with texts by Eric Michaud, Didier Semin and Christian Tarting

Musée Saint Pierre, Art Contemporain, Lyon, *Lyon: Octobre des arts 1985*, October 1985. Catalogue

Villa Géo-Charles, Echirolles, *Du petit*, 1985

B.I.G., Berlin, *Art français: Positions*, February 8-23, 1986. Catalogue with texts by Jean de Loisy and Hans-Peter Schwerfel and interviews with the artists by Philippe Cyroulnik, Jean de Loisy, Paul-Hervé Parsy and Joëlle Pijaudier

Fondation Cartier, Jouy-en-Josas, *Sur les murs*, February 23-May 4, 1986. Catalogue

Montrouge, *XXXI Salon de Montrouge*, April-May 1986

Selected One-Man Exhibitions

Galerie Napalm, Saint Etienne, June 1981

Musée d'Art et d'Industrie, Saint Etienne, *Philippe Favier*, March 29-April 30, 1982. Catalogue with texts by Bernard Ceysson and Gilbert Lascault

Galerie C. le Chanjour, Nice, July 5-31, 1983

Galerie Farideh Cadot, Paris, September 17-October 10, 1983; September-October 1985

Galerie Grita Insam, Vienna, November 5-December 2, 1983

Halle Sud, Geneva, May 7-June 2, 1985

Galerie Alma, Lyon, *Capitaine Coucou*, October 2-31, 1985. Catalogue with text by Eric Darragon

Musée de l'Abbaye de Sainte Croix, Sables-d'Olon-ne, *Philippe Favier: 1980-1985*, July 5-September 14, 1986. Catalogue with texts by Daniel Abadie, Jacques Bonnaval, Louise Ferrari, Jean-Claude Lebensztein, Eric Michaud and Guy Tosatto. Traveled to Villa Arson, Nice, October 10-December 12; Musée de Rochechouard, Limoges

Selected Bibliography

Didier Semin, "Une Source de Philippe Favier," *Avant-Guerre*, no. 3, 1981

Inès Champey, "Philippe Favier," *Art Press*, no. 58, April 1982, p. 12

Jean-Marc Poinsot, "New Painting in France," *Flash Art* (International), no. 108, Summer 1982, pp. 40-44

Hervé Gauville, "Parmi cent autres, Philippe Favier," *Libération*, October 1, 1982, p. 26

Jean de Loisy, "New French Painting," *Flash Art* (International), no. 110, January 1983, pp. 44-48

Christian Caujolle, "Philippe Favier, petit bonhomme," *Libération*, October 4, 1983, p. 29

Maïten Bouisset, "Suivez mon regard," *Le Matin*, October 14, 1983, p. 32

Patrice Bloch and Laurent Pesenti, "Fiac, 10ème anniversaire: Philippe Favier," *Beaux-Arts Magazine*, no. 6, October 1983, pp. 54-58

Elisabeth Couturier, "Philippe Favier, Galerie Farideh Cadot," *Art Press*, no. 75, November 1983, p. 52

Jacques Bonnaval, "Philippe Favier," *Axe Sud*, no. 7, Winter 1983

Valère Nuther, "Ce qui est dit est à retaire: Entretien avec Philippe Favier," *Halle Sud*, no. 8, April 1985, pp. [2-3]

Mireille Descombes, "Les Microcosmes de Favier," *Tribune de Genève*, May 17, 1985

"Miniatures, Samba figurative," *L'Hebdo*, May 23, 1985, p. 83

Françoise-Claire Prodhon, "Philippe Favier," *Flash Art* (France), no. 7-8, Spring-Summer 1985, pp. 68-69

"Douze Artistes dans l'espace," *Art Press*, no. 94, July-August 1985, p. 24

François-Yves Morin, "Philippe Favier: La Peinture en minuscules," *Mars*, no. 6, Summer 1985, pp. 16-17

Olivier Céna, "Philippe Favier, Légumes étranges et flamant rose," *Télérama*, October 2, 1985, p. 45

Henri-François Debailleux, *Beaux-Arts Magazine*, no. 28, October 1985, p. 2

Jean-Luc Chalumeau, "Et que tout soit pareil et que tout soit autre chose," *Eighty*, no. 11, January-February 1986, pp. 60-61

Catherine Flohic, "Portrait," *Eighty*, no. 11, January-February 1986, p. 63

Sonia Criton, "Philippe Favier," *Flash Art* (France), no. 10, March 1986, p. 36

39 *IRIS.* 1981
 Acrylic on cutout paper, 5½ x 4¾″
 Collection Musée de Toulon

40 *Untitled (Sans titre)*. 1982
 Acrylic on cutout paper, 4 x 4″
 Courtesy Galerie Farideh Cadot, Paris

41 *Untitled (Sans titre).* 1985
 Acrylic on cutout paper and glass, 11¾ x 8″
 Courtesy Galerie Farideh Cadot, Paris

42 *Captain Cook (Capitaine Coucou).* 1985
Etching, 2⅜ x 4³⁄₁₆″
Courtesy Galerie Farideh Cadot, Paris

43 *Imported from Spain (Importé d'Espagne).* 1984
Etching, 3³⁄₁₆″ diameter
Courtesy Galerie Farideh Cadot, Paris

44 *Self Portrait with Camembert and Cherries*
 (Autoportrait au camembert et cerises). 1985
 Stained-glass color and ceramic glaze on glass,
 4¼ x 2¾″
 Courtesy Galerie Farideh Cadot, Paris

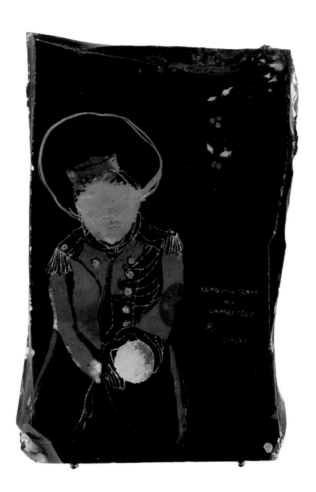

45 *The Folding Screens (Les Paravents).* 1985
Stained-glass color and ceramic glaze on glass, 5 x 9″
Courtesy Galerie Farideh Cadot, Paris

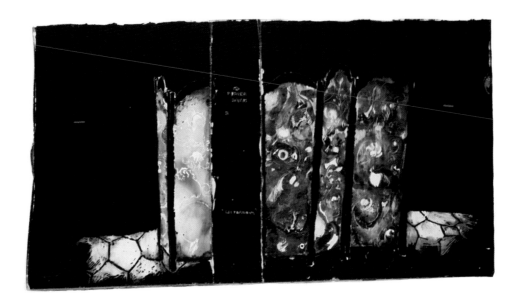

46 *The Folding Screens (Les Paravents).* 1985
Stained-glass color and ceramic glaze on glass,
4¾ x 7″
Courtesy Galerie Farideh Cadot, Paris

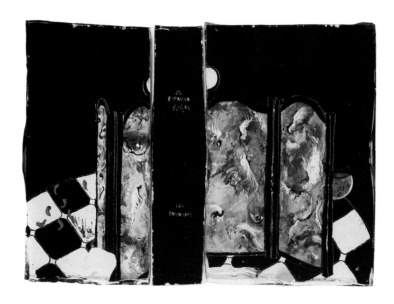

47 *Still Life with Vitamin C (Nature morte à la vitamine C).*
1986
Stained-glass color and ceramic glaze on glass,
5½ x 8¼"
Courtesy Galerie Farideh Cadot, Paris

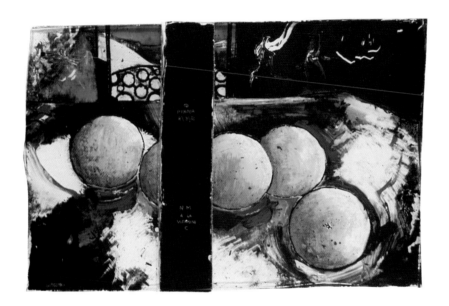

48 *The Winds (Les Vents).* 1986
 Stained-glass color and ceramic glaze on glass,
 4½ x 8¼"
 Collection Musée National d'Art Moderne,
 Centre Georges Pompidou, Paris

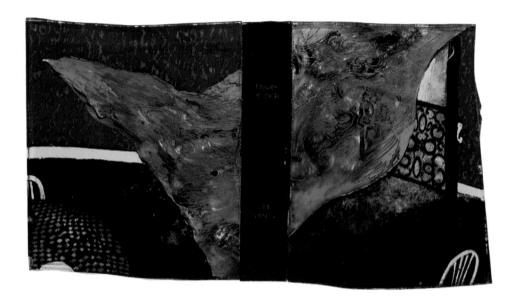

Ange Leccia

Ange Leccia began making "arrangements" after devoting many years to painting, film, performance and video. In this departure from previous modes, he places different elements together, setting up relationships between them yet always preserving the integrity of the individual components. From the encounter between two objects or between object and space, the work of art is born. Leccia insists on the distinction between what he calls "arrangement" and installation: "To install is much more physical, more rigid. The word 'arrangement' implies the will to respect things; when I say 'arrange,' there is an element of modesty. I arrange = I choose. 'Arrangement' is a little like plotting one's position amid the stars to set one's course with a sextant: the precise measurement that reveals the right direction. To arrange is to establish the relationship, the exact position."[1]

The notion of the encounter is of key significance in Leccia's oeuvre. Perhaps his most effective and indeed poignant treatment of this concept is seen in *Arrangement "The Kiss" (Arrangement "Le Baiser")* of 1985 (cat. no. 54). Here, two illuminated projector lights are stationed face to face in an otherwise empty space. Between these inanimate objects an intimate interchange, an actual physical contact takes place, which, as the title suggests, approximates the act of kissing. Further, the lights transmit heat, and the warmth exchanged between them radiates throughout the space. Confronted by such startling intimacy, we instinctively shrink from it and thus distance ourselves from the work; however, we cannot ignore the acute human dimension the artist has imparted to these machines, which causes them to transcend their technological function. As emotional in content as it is simple in means, this piece is a testament to Leccia's contention that the role of the artist is to provoke an emotion, even with only machines at his disposal. He says, "I do not want to be simply a mediator of elements; I want feeling to always be present."[2]

Leccia has extended the powerful image of the kiss to other situations in which the contact point between objects generates a similar tension and electricity. In a work executed at the Centre National d'Art Contemporain, Grenoble, in 1986 (cat. no. 56), the artist parked two Volvo automobiles head on, their front fenders just touching. The headlights were fully ablaze, and the redoubled force of their beams produced a profound sense of energy. An even more majestic realization of this concept will be carried out later this year in Toulouse: two Concorde jets will be positioned so as to meet at the infinitesimally small points of their elegantly tapered beaks. Despite the aggrandizement of the images in these two instances, the idea retains all the clarity and poetry of the original conception. Leccia continually stresses the modesty of his proposals which serve, in his words, "to illuminate the simplicity of things."[3]

Light is an essential element of the artist's oeuvre: it makes visible, clarifies, focuses and, finally, dazzles. Leccia describes his light as ". . . light that is domesticated yet which retains its original powers: to caress the retina, to dazzle. It is concentrated energy."[4] Light is the protagonist of *Arrangement*, 1984 (cat. no. 50), in which the artist positions two slabs of marble on the floor; from the end of one of these slabs, a portion has been cut away. He directs the light of a projector to strike this void, thereby re-creating the missing section. In this instance, the power of the light is used to reunite

the two segments, to make the marble whole again. Despite its immateriality, the light seems as substantial as the stone it replaces. Similarly, in *Arrangement*, 1985, Leccia uses projectors to beam light at the lowest level of a stack of cement blocks, thus creating the illusion that the weighty bricks are floating on a base of light. Here the artist was attracted by the notion of uniting objects that are involved in some way with construction: a projector gives form to images; a brick is a building material. He says of this work, "I had to find the arrangement, the exact position, bring about the meeting. Each time is a confrontation with oneself, a calling into question; I have to find the precise point where things marry."[5]

In his use of film projectors Leccia has shown us that practically any material can accept projected light. He continues his explorations in this vein working with screens. For example, the artist is fascinated by television "snow"—the crackling grisaille created on a screen when there is no program. In *Arrangement*, 1985 (cat. no. 53), he places an illuminated television inside a well-like structure of concrete blocks; more blocks are heaped inside the well, almost completely burying the television so that only a portion of its screen remains visible. The sound of the static produced by the snow evoked running water, and the blue light reinforced this metaphor, suggesting a deep pool of water. In *Arrangement "Séance"* (cat. no. 55) Leccia placed fifty projectors on fifty chairs set up in rows. Though empty of film, all the machines were running, shining their beams directly onto the backs of the chairs —the screens—in front of them. The vibrating projected light became the image, which in concert with the steady hum of the machines released a palpable energy that filled the auditorium-like space. Leccia evoked the tension peculiar to a movie theater, re-creating without human presence the attentive audience focused on the image on the screen before it. In a more sculptural variation on this theme, Leccia erected an imposing column of steel-gray film canisters. Within this hollow form he placed a running projector, so that the approaching viewer would be drawn to the clicking sound that echoed inside the walls. The impression created was that of a beating heart, a palpitating warmth that contrasted strikingly with the cold and austere metal casing. The rapport between the film canisters and the projector is re-created in *Arrangement*, 1986 (cat. no. 52), which involves televisions and their cardboard packing-cases. Here again, with materials of modern technology, Leccia forges a primitivistic totem. Four televisions are situated at the base of a stack of their cartons. They face inward and, denied the opportunity of projecting an image, emit a diffuse light that transforms the mundaneness of the cardboard and thus reverses the hierarchy of importance that normally exists between an object and its packaging.

Images never appear in Leccia's oeuvre. His work is based on blank screens, televisions without programs, sounds without messages, lights that merely illuminate other lights. He uses objects that traditionally give access to images and sounds, yet he denies us this access. Leccia searches for something more profound than narration, and discovers it in the simplicity and poetry of his unique vision.

1. Interview with the artist by Laurence Bossé and Suzanne Pagé in *Ange Leccia*, 1985, unpaginated.
2. Ibid.

3. Ibid.

4. Ibid.

5. Ibid.

Biographical Information

Born in Minerviu, Corsica, April 19, 1952

Lycée Artistique de Bastia, Corsica, 1962-71

Faculté des Arts Plastiques, Paris I-Saint Charles, 1972-76

Artist in Residence, Villa Medici, Rome, 1981-83

Lives and works in Paris

Selected Group Exhibitions

Ridotto Venier, Venice, June 1982

Galleria Nazionale d'Arte Moderna, Rome, *Quattro Accademie Straniere*, July 28-October 30, 1982. Catalogue

Villa Medici, Rome, *Nell'Arte: Artisti italiani e francesi a Villa Medici*, June 8-July 8, 1983. Catalogue with text by Achille Bonito Oliva

Institut Curie, Paris, *A Pierre et Marie: Une Exposition en travaux*, December 4, 1983-October 21, 1984

Palazzo di Città, Acireale, Sicily, *La Scuola di Atene*, December 1983. Catalogue with texts by Achille Bonito Oliva and Jean-Louis Maubant. Traveled to Galleria Borghese, Rome, February 1984; Galleria Civica d'Arte Moderna, Palazzo dei Diamanti, Ferrara, March

Le Nouveau Musée, Lyon-Villeurbanne [exhibition untitled], June 23-September 20, 1984. Catalogue with texts by Michel Claura, Bertrand Lavier, Jean-Louis Maubant, Sarkis and Daniel Soutif

F.R.A.C. Aquitaine, Bordeaux (organizer), *Lumières et sons*, Château de Biron, Dordogne, June 23-September 22, 1984

Pavillon des Arts, Paris, *Génération Polaroid*, February 14-March 17, 1985. Catalogue with text by Michel Nuridsany

Kulturhuset Galleriet, Stockholm, *En ny Generation i fransk konst*, March 8-May 27, 1985. Catalogue with texts by Beate Sydhoff and Henri Sylvestre

F.R.A.C. Midi-Pyrénées, Toulouse (organizer), *Sagas, versant sud: Parcours dans l'art d'aujourd' hui de Bordeaux à Nice*, Palau Meca, Barcelona, June 18-July 28, 1985. Catalogue

36, Avenue du Président Wilson, Paris, *Six Heures avant l'été*, June 20-July 20, 1985

Galerie Montenay-Delsol, Paris, June 30-July 31, 1985

Musée Municipal de La Roche-sur-Yon, *Sols/Murs*, September 13-October 19, 1985. Traveled to Musée Ancien Evêché, Evreux, November 15, 1985-January 5, 1986

F.R.A.C. Pays de la Loire, Fontevraud (organizer), *Ateliers internationaux des Pays de la Loire*, Abbaye Royale de Fontevraud, October 19-November 21, 1985. Catalogue with texts by Pierre Giguel, Patrick Javault and Jean de Loisy

Centre de Création Contemporaine, Tours, *France-Tours, art actuel: Deuxième Biennale nationale d'art contemporain*, November 29, 1985-January 6, 1986. Catalogue with texts by Didier Larnac, Loïc Malle, Philippe Piguet, Delphine Renard and Jérôme Sans and interview with Skimao by Christian Laune

B.I.G., Berlin, *Art français: Positions*, February 8-23, 1986. Catalogue with texts by Jean de Loisy and Hans-Peter Schwerfel and interviews with the artists by Philippe Cyroulnik, Jean de Loisy, Paul-Hervé Parsy and Joëlle Pijaudier

Sala Una, Rome, *Ici Rome . . . A vous Paris*, March 1-22, 1986

Centre National d'Art Contemporain, Grenoble, April 26-May 25, 1986. Catalogue

Maison de la Culture de Rennes, *Au seuil de l'ombre*, April 25-May 25, 1986. Catalogue

Le Nouveau Musée, Lyon-Villeurbanne, *Collection souvenir*, April 30-September 21, 1986

Castello di Canino, Volci, Italy, *Mandelzoom*, June 21-October 1986. Catalogue with text by Antonio d'Avossa

Le Centre Culturel and Passages, Troyes, *Obscur-Obscurité-Obscurcissement*, June 25-August 29, 1986

La XLII Biennale di Venezia: Aperto 86. Nuit bleue, June 29-September 28, 1986. Catalogue with texts by Suzanne Pagé and Daniel Soutif

Centre International d'Art Contemporain, Montreal, *Lumières: Perception, projection*, August 1-November 2, 1986. Catalogue

Selected One-Man Exhibitions

Galerie du Haut Pavé, Paris, May 13-June 7, 1980

Galerie Lucien Durand, Paris, March 19-April 11, 1981; February 7-March 10, 1984. Catalogue with text by Marie-Laure Bernadac

Galleria Arco d'Alibert, Rome, October 25-December 1983

Galleria Deambrogi, Milan, June 4-July 4, 1984

Espace Lyonnais d'Art Contemporain, Lyon, February 25-March 10, 1985

A.R.C., Musée d'Art Moderne de la Ville de Paris, *Ange Leccia*, June 27-September 22, 1985. Catalogue with texts by Laurence Bossé and Suzanne Pagé

Ecole des Beaux-Arts, Mâcon, *Ange Leccia*, October 7-November 10, 1985. Catalogue with texts by Jean-Louis Maubant and Ida Minnini

College of Art and Design, Halifax, Nova Scotia, Canada, June 1985

Atheneum, Dijon, November 13-December 10, 1985

Galerie Arlogos, Nantes, February 22-March 22, 1986

Selected Bibliography

Jean-Marie Tasset, "Leccia: Un Point c'est tout," *Le Figaro*, April 1, 1981, p. 23

Maïten Bouisset, "Ange Leccia," *Le Matin*, April 4, 1981

Claude Bouyeure, "Ange Leccia," *Politique Hebdo*, April 28, 1981

Orsan, "Ange Leccia," *Rock en stock*, April 1981

Lorenzo Mango, "Il ricordo dell'occhio," *Paese Sera*, November 15, 1983

David O'Brien, "The Roman Art Scene," *Daily American*, November 24, 1983

Lisa Licitra Ponti, "Fame 5," *Domus*, no. 643, October 1983, p. 74

Jean-Marie Tasset, "Leccia: Point à l'image," *Le Figaro*, February 10, 1984, p. 24

Jean-Pierre Bordaz, "Ange Leccia," *Beaux-Arts Magazine*, no. 10, February 1984, p. 84

Gaya Goldcymer, "Ange Leccia: D'Une Mémoire à l'autre," *Art Press*, no. 82, June 1984, p. 19

Catherine Strasser, "Histoire de sculptures/Lumières et sons," *Art Press*, no. 84, September 1984, p. 47

Arielle Pélenc, "Pour en finir avec la bêtise du peintre," *Artistes*, no. 24, October 1984, pp. 110-115

Florence Sebastiani, "Vidéo à la Villa Médicis," *Sonovision*, no. 269, 1984

Daniel Soutif, "Ange Leccia, artiste corse," *Libération*, August 14, 1985, p. 24

Elisabeth Lebovici, "L'Anémique Cinéma d'Ange Leccia," *L'Evènement du Jeudi*, August 1985

Delphine Renard, "Sagas, Palau Meca," *Art Press*, no. 95, September 1985, p. 60

Catherine Francblin, "Anselmo, Leccia, Weiner," *Art Press*, no. 96, October 1985, p. 70

Corinne Pencenat, "Six Heures avant l'été," *Art Press*, no. 96, October 1985, p. 70

Mona Thomas, "Ange Leccia, portrait," *Beaux-Arts Magazine*, no. 30, December 1985, pp. 90-91

Philippe Piguet, "Ange Leccia," *Flash Art* (France), no. 9, Autumn 1985, p. 31

Michel Nuridsany, "Ange Leccia: L'Ecran du rêve," *Public*, no. 3, 1985, pp. 66-69

Pierre Giquel, "Philippe Dufour, Ange Leccia: Galerie Arlogos," *Art Press*, no. 103, May 1986, p. 66

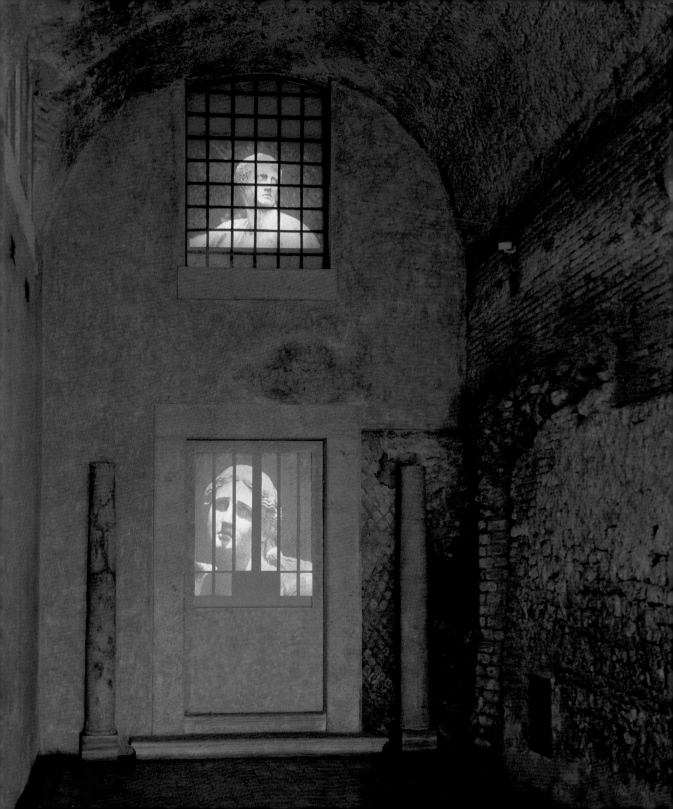

49 *Arrangement.* 1983
Videoprojection, Villa Medici, Rome

50 *Arrangement.* 1984
 Marble slabs and film projector
 Le Nouveau Musée, Lyon-Villeurbanne

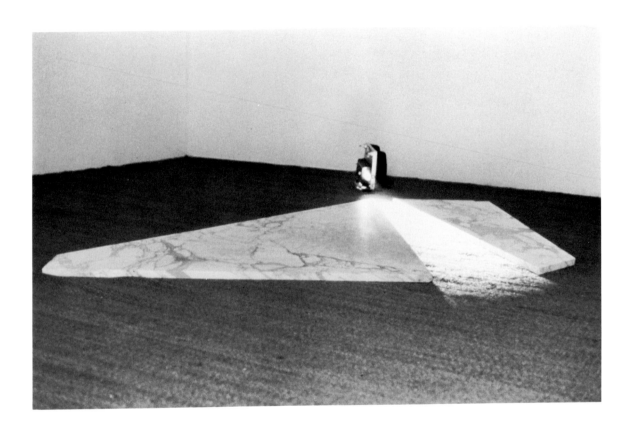

51 *Arrangement*. 1985
 Cement blocks and film projectors
 Kulturhuset Galleriet, Stockholm

52 *Arrangement.* 1986
Televisions and cardboard packing cartons
Sala Una, Rome

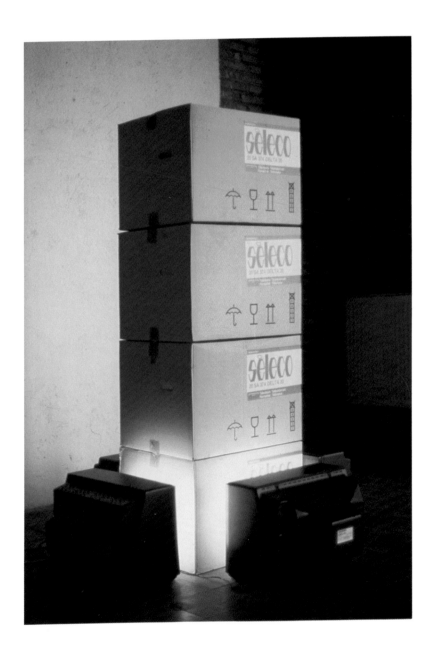

53 *Arrangement.* 1985
Cement blocks and television
Galerie Montenay-Delsol, Paris

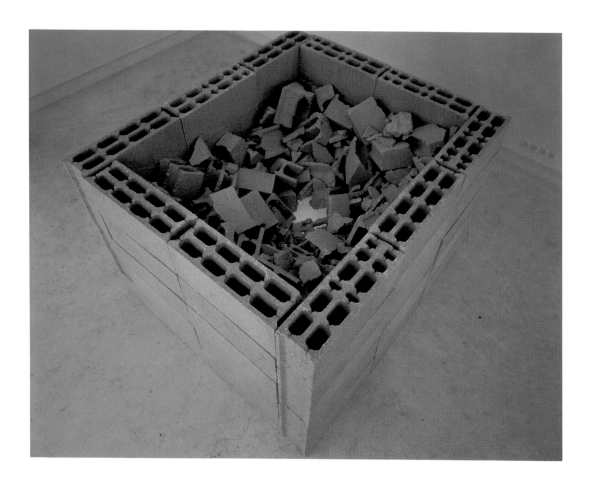

54 *Arrangement "The Kiss" (Arrangement « Le Baiser »).* 1985
Cremer projector lights
Courtesy Galerie Montenay-Delsol, Paris

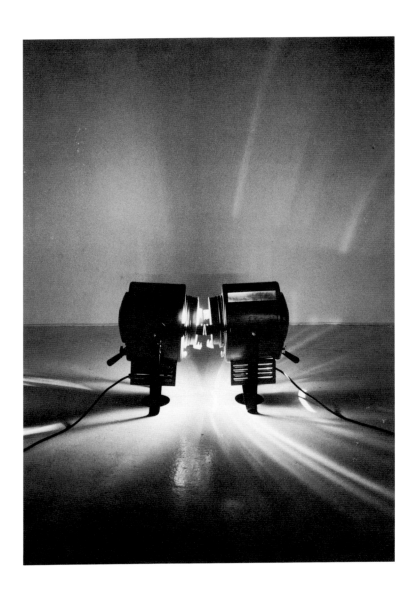

55 *Arrangement "Séance."* 1985
 Film projectors and chairs
 A.R.C., Musée d'Art Moderne de la Ville de Paris

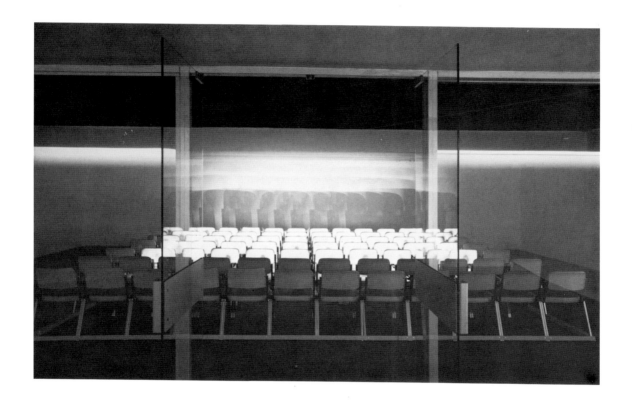

56 *Arrangement.* 1986
 Volvo cars
 Centre National d'Art Contemporain, Grenoble

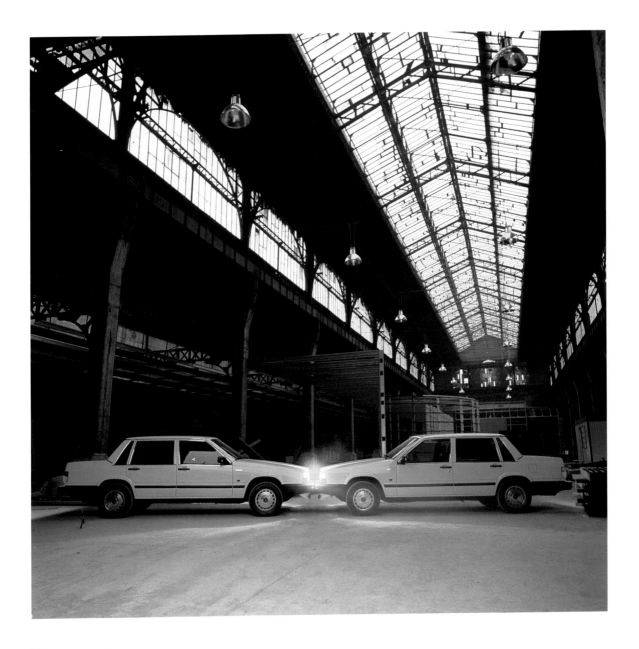

57 *Arrangement.* 1986
Televisions, cardboard packing cartons and voile
Palazzo delle Prigioni, *La XLII Biennale di Venezia*

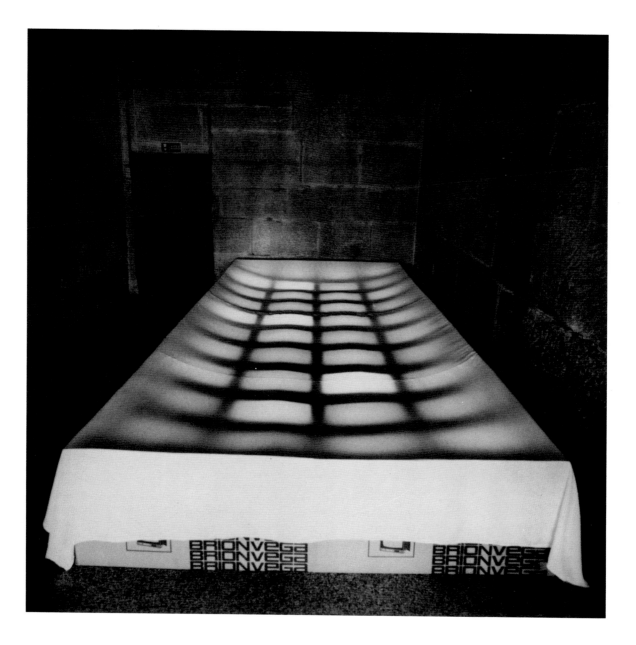

Georges Rousse

Georges Rousse has chosen to locate his studio amid ruins—not those of antiquity, but those of the modern world, such as abandoned factories, warehouses, airplane hangars, that bear the scars of their former occupants. These sites, condemned to demolition, are given one last (and lasting) incarnation by the artist. Working with the materials of the ruins, with their light and colors, with their own particular poetry, Rousse evokes their former states and invests them with new life in his large-scale color photographs. He explains, "Abandoned buildings, mostly closed and forbidden, have always fascinated me as playgrounds and adventure spots. Places to dream but also disturbing, where you never know what you are going to discover nor whether they are inhabited or visited, with strange atmospheres and a strong emotional impact.... These places where I work provoke a shock which will be transformed into a story, a vision, without really knowing whether what I recount is linked to the place or to myself."[1]

To effect this transformation, Rousse paints or affixes painted paper on the interior surfaces of these structures—walls, floors, windows, ceilings, pillars and staircases are all eligible supports. These interiors and their painted elements are never directly revealed to the public eye, however. Rousse photographs them, and the photographic representation alone constitutes the work of art. It is the intervention of the camera that imbues both the painting and the environment itself with significance. The artist imposes his point of view on us through the photograph—in the framing, focus and use of close-up or long shot. By choosing to reveal only a glimpse of the environment in its current transformed state, Rousse invites us to view a mo-

ment in time, forever captured. And then the bulldozers arrive.

In form and iconography, Rousse's painted subjects are adapted to the architectural components upon which they are imposed. From 1981 to 1984 his emphasis was on the figurative, in the spirit of the prevailing Neo-Expressionist style (see cat. no. 58). In these works the bold shapes, expressive silhouettes and jarring colors of the figures blend with the particular texture of the decaying walls, peeling paint and rotted beams of the interiors they inhabit. Like giant phantoms that have invaded these deserted places, the figures revive the space with their acrobatic maneuvers. Their distorted bodies, foreshortened and elongated at the same time, resist the pull of gravity and float weightlessly. Even the click of the shutter does not rob them of their freedom and spontaneity.

Since 1984 the pictorial aspect of Rousse's oeuvre has given way to a more complex and abstract orientation. Simple geometric forms such as arches, crosses, cones and cubes play against the architectural elements of the spaces to create trompe l'oeil perspectival effects. These forms, drawn in colored chalks, have an immateriality by virtue of the semitransparent skeins of cross-hatching that define them. Like the earlier painted figures, they seem to float, disembodied. Yet their fictive volumes are superimposed on real volumes —for example the two intersecting v-shaped forms that encase the column in *Untitled (Sans titre),* Paris, 1984 (cat. no. 60)—to create a powerful illusion. In this photograph the complex geometric shape appears to exist in three dimensions in the center of the room even though it is drawn in two dimensions on different horizontal and vertical surfaces. The

optical reconstruction is achieved through anamorphosis from the fixed, specific viewpoint of the camera eye. Thus the configuration remains uncrystallized except when seen from the one point of view the camera allows. Rousse's more recent work involves a further complication of perspective through the use of mirrors. In works such as *Untitled (Sans titre)*, Geneva, 1985 (cat. no. 63), he draws his geometric forms behind as well as in front of the camera. He then places mirrors (in this case, two) in the space in front of the camera in order to capture both the real and reflected images on the single plane of the photograph. By varying the size and arrangement of the mirrors, Rousse is able to extend his complex and exciting explorations of space and light.

Not only the optical illusions but also the magic and suggestive qualities of his color and light distinguish Rousse's latest work from his earlier endeavors. Although the range of colors of chalk is limited, he endows these scenes with a light that seems to absorb the local colors of the site and synthesize them, creating the monochromatic but richly graded tonality of the final print. At this point, color and light become inseparable.

Rousse has said that photography is for him a means of gathering together diverse experiences. And it is indeed true that his creative process involves painting, sculpture, installation and photography. Yet it is only through the unique perception of the camera that these media coalesce into the final image. By abolishing the distinction that separates original work and photographic reproduction, Rousse seeks to give new definition to the possibilities of photography.

1. *Art français: Positions*, 1986, p. 107.

Biographical Information

Born in Paris, July 28, 1947

Grant from French Government to work at P.S. 1, The Institute for Art and Urban Resources, Long Island City, New York, 1982

Drawings Prize, *XXXI Salon de Montrouge*, May 1986

Lives and works in Paris and Rome

Selected Group Exhibitions

Galerie de France, Paris, *Des photographies dans les paysages*, April-May 1981

Galerie d'Art Contemporain des Musées de Nice, *L'Air du temps: Aspects de la Figuration Libre en France*, February 27-April 11, 1982. Catalogue with texts by Xavier Girard, Otto Hahn and Marc Sanchez

Galerie Farideh Cadot, Paris, *Un Regard autre II*, February-March 1982

Art Prospect, Paris (organizer), *Réseau Art*, posters and billboards commissioned for public display in France, June 1-15, 1982. Catalogue with texts by Jean-Louis Connan and Alain Garo

Montrouge, *XXVII Salon de Montrouge*, June 1982

Nicola Jacobs Gallery, London, June 1982

Musée de Toulon, *Quatre Ans d'acquisitions*, July 1982. Catalogue

A.R.C., Musée d'Art Moderne de la Ville de Paris, *XII Biennale de Paris*, October 1982. Catalogue with texts by Jacques Louis Binet, Dany Bloch, Catherine Francblin, Monique Kissel, Carole Naggar and Jean-Marc Poinsot. Traveled in part to Sara Hildenin Taidemuseo, Tampere, Finland, January 1983; Kunstnernes Hus, Oslo, March

Espace Lyonnais d'Art Contemporain, Lyon, *Figures imposées*, January 25-March 20, 1983. Catalogue with texts by Bernard Ceysson, Xavier Girard, Hervé Perdriolle and Didier Semin

Kunstlerhaus, Stuttgart, *Au pied du mur*, January 1983

Musée de Nice, *10 Ans d'acquisitions*, January 1983

Musée National d'Art Moderne, Centre Georges Pompidou, Paris, *Images fabriquées,* February 10-March 13, 1983. Catalogue. Traveled to Musée des Beaux-Arts, Nantes, November 4-December 23; Musée d'Art Actuel, Hasselt, Belgium, June 8-July 8, 1984

Galerie Athanor, Marseille, *Marseille art présent*, February 31-April 30, 1983. Catalogue

Centre de Création Contemporaine, Tours, *France-Tours, art actuel: Première Biennale d'art contemporain*, April 22-May 29, 1983. Catalogue with texts by Jean-Christophe Ammann, Marie-Claude Beaud, Michel Giroud, Giovanni Joppolo, Alain-Julien Laferrière, Bernard Lamarche-Vadel and Jean de Loisy

Gabrielle Bryers Gallery, New York, May 1983

Musée Sainte-Croix, Poitiers, *Photographies de la collection Bernard Lamarche-Vadel*, May-June 1983. Catalogue with texts by A. Class and Bernard Lamarche-Vadel

Galerie Verrière, Lyon, *Propositions 83*, June 1983

Musée des Augustins, Toulouse, *Trace empreintes*, June 1983

Espace Niçois d'Art et de Culture, Nice, *Peindre et photographier*, July 7-September 30, 1983. Catalogue with texts by Claude Fournet and Philippe Mezescaze

A.F.A.A. (Association Française d'Action Artistique), Paris (organizer), *Arte Francés Contemporaneo*, Museo Sivori, Buenos Aires, July 13-August 3, 1983; Museo Nacional de las Artes Plásticas y Visuales, Montevideo, August 10-September 4; Museo del Banco Central, Lima, September 24-October 20; Casa de la Cultura, La Paz, November

Musée de Bourbon-Lancy, *Nouvelle peinture*, July 1983

Zabriskie Gallery, New York, *Three French Artists*, July-September 1983

Art Prospect, Paris (organizer), *Réseau Art 83*,

posters and billboards commissioned for public display in France, August 1-15, 1983

A.F.A.A. (Association Française d'Action Artistique), Paris (organizer), *New French Painting*, Riverside Studios, London, October 1983; Gimpel Fils, London, November 22-December 22; Museum of Modern Art, Oxford, January 22-March 25, 1984; John Hansard Gallery, University of Southampton, May 8-June 9; Fruitmarket Gallery, Edinburgh, June 30-August 4. Catalogue with texts by Bernard Ceysson, Marco Livingstone and Jérôme Sans

Galerie Krinzinger, Innsbruch, *Neue Bilder aus Frankreich*, November 1983. Traveled to Kunstverein, Frankfurt, December 1983

F.R.A.C. Pays de la Loire, Fontevraud, *Nouvelles Acquisitions du F.R.A.C. des Pays de la Loire*, January 13-February 3, 1984

Hôtel de Ville, Paris, *France, une nouvelle génération*, January-March 1984. Catalogue with text by Catherine Millet

Centre National d'Art Contemporain, Paris, *Acquisitions F.R.A.C. Rhône-Alpes*, February 1984

Fisher Art Gallery, University of Southern California, Los Angeles, *French Spirit Today*, March 19-April 21, 1984. Catalogue with texts by Jean-Louis Froment and Catherine Strasser. Traveled to Museum of Contemporary Art, La Jolla, California, June 16-August 3

Art Gallery of New South Wales, Sydney, *The Fifth Biennale of Sydney. Private Symbol: Social Metaphor*, April 11-June 17, 1984. Catalogue with texts by Stuart Morgan, Annelie Pohlen, Jean-Louis Pradel, Carter Ratcliff and Netty Richard

Maison de la Culture de Saint Etienne, *Murs blancs pour une chambre noire*, April 1984

A.F.A.A. (Association Française d'Action Artistique), Paris, and Ministero per i Beni Culturali e Ambientali, Rome (organizers), *Individualités, artisti francesi d'oggi*, Galleria Nazionale d'Arte Moderna, Rome, May 29-July 22, 1984

F.R.A.C. Lanquedoc-Roussillon, Montpellier,

Rencontres internationales de la photographie et de l'audiovisuel, May 1984

Kunstmuseum Basel, *Perspectives*, June 14-18, 1984

San Francisco Museum of Modern Art, *The Human Condition: S.F.M.M.A. Biennial III*, June 28-August 26, 1984. Catalogue with texts by Achille Bonito Oliva, Wolfgang Max Faust, Edward Kienholz, Dorothy Martinson and Klaus Ottman

Musée de Brou, Bourg-en-Bresse, *La Peinture refigurée*, June 28-September 2, 1984

Galerie C. le Chanjour, Nice, June 1984

Galerie d'Art Contemporain des Musées de Nice, *Nice: L'Art contemporain au musée*, September 29-November 18, 1984

Hirshhorn Museum and Sculpture Garden, Smithsonian Institution, Washington, D.C., *Content: A Contemporary Focus, 1974-1984*, October 4, 1984-January 6, 1985. Catalogue with texts by Howard N. Fox, Miranda McClintic and Phyllis Rosenzweig

F.R.A.C. Pays de la Loire, Fontevraud (organizer), *I Ateliers internationaux de Fontevraud*, Abbaye Royale de Fontevraud, October 27-December 11, 1984. Catalogue with texts by Michel Enrici, Bernard Martin et al.

Fondation Charles Jourdan, Paris, *L'Hôtel revisité*, October 1984

Cabinet des Estampes, Geneva, *Nouvelles Acquisitions*, November 1984

Pavillon des Arts, Paris, *Génération Polaroid*, February 14-March 17, 1985. Catalogue with text by Michel Nuridsany

Centre National des Arts Plastiques, Paris (organizer), *Le Style et le chaos*, Musée du Luxembourg, Paris, March 1-April 30, 1985. Catalogue with text by Jean-Louis Pradel

Künstlerwerkstatt, Munich, *Rendez-vous*, April 30-May 27, 1985. Catalogue with text by Marie-Luise Syring

A.F.A.A. (Association Française d'Action Artistique), Paris (organizer), *Exposition d'art français con-*

temporain, douze artistes français dans l'espace, Seibu Museum of Art, Tokyo, May 20-June 23, 1985; O'Hara Museum, Kurachiki, July 12-August 4

Porin Taidemuseo, Finland, *International Photography Today*, May 23-July 14, 1985

Galerie Pierre Lescot, Paris, *Téléphone graffiti*, June 5-July 12, 1985

Maison des Arts, Belfort, *Les Territoires de la Biennale*, June 1985

Chiostri della Logetta Lombardesca, Ravenna, *Amiottanta*, July 4-September 30, 1985. Catalogue with texts by Daniel Abadie and Susanna Zanuso

Musée de l'Hospice Comtesse, Lille, *Collection de F.R.A.C. Nord-Pas de Calais*, November 9-December 30, 1985

Musée National d'Art Moderne, Centre Georges Pompidou, Paris, *Photographie contemporaine en France*, November 28, 1984-January 27, 1985. Catalogue with texts by Agnès de Gouvion St. Cyr and Alain Sayag

Galerie Nationale du Grand-Palais, Paris, *Anciens et nouveaux*, November 1985

Musée d'Art Contemporain de Bordeaux, *Aimer les musées*, November 1985

B.I.G., Berlin, *Art français: Positions*, February 8-23, 1986. Catalogue with texts by Jean de Loisy and Hans-Peter Schwerfel and interviews with the artists by Philippe Cyroulnik, Jean de Loisy, Paul-Hervé Parsy and Joëlle Pijaudier

Villa Arson, Nice, *Pictura Loguens: 25 Ans d'art en France vu par Gérard Georges Lemaire*, February 15-April 13, 1986

Fondation Nationale des Arts Graphiques et Plastiques, Paris, *Créations Pour un F.R.A.C. (Pays de la Loire)*, April 29-June 8, 1986

Galerie C. le Chanjour, Nice, April 1986

Montrouge, *XXXI Salon de Montrouge*, April-May 1986

Comune di Milano (organizer), *Arte in Francia:*

1960-1985, Palazzo Reale, Milan, June 30-
September 7, 1986

C.I.R.V.A. (Centre International de Recherche sur
le Verre et l'Art), Aix-en Provence, *Atout Verre*,
July 11-September 30, 1986

Selected One-Man Exhibitions

Cabinet des Estampes, Bibliothèque Nationale,
Paris, *Georges Rousse*, December 7, 1981-
January 23, 1982

Nicola Jacobs Gallery, London, *Georges Rousse*,
February 1982

Galerie Farideh Cadot, Paris, *Georges Rousse*,
January 8-February 1, 1983; September 15-
October 15, 1984; November 16, 1985-January 15,
1986; September-October

Centre des Arts Plastiques Contemporains, Musée
d'Art Contemporain de Bordeaux, *Georges Rousse*,
Photographies, March 18-April 23, 1983

Galerie Grita Insam, Vienna, *Georges Rousse*,
January 1984; *Georges Rousse Kunst Raum Wien*,
November 5-December 5, 1985

The Quay Gallery, San Francisco, *Georges Rousse*,
March 5-30, 1984

Comédie de Caen, Centre Dramatique National de
Normandie, *Georges Rousse*, April 2-30, 1984

Musée Municipal de La Roche-sur-Yon, *Georges
Rousse*, May 16-June 16, 1984. Catalogue with text
by Catherine Strasser

Galerie Michael Haas, Berlin, *Georges Rousse*,
July 1984

Halle Sud, Geneva, *Georges Rousse*, September
7-30, 1984

Annina Nosei Gallery, New York, *Georges Rousse*,
September 11-October 11, 1984

Mendelsohn Gallery, Pittsburgh, Pennsylvania,
September 1984

Musée des Beaux-Arts d'Orléans, *Georges Rousse*,
April 19-June 3, 1985. Catalogue with interview
with the artist by Jean de Loisy

Galerie Graff, Montreal, *Georges Rousse,
photographies,* May 29-June 26, 1985

Association du Mejan, Arles (organizer), *Georges
Rousse*, Eglise Saint Martin-du-Mejan, May 17-
July 15, 1986

Selected Bibliography

Michel Nuridsany, "Georges Rousse," *Art Press*,
no. 58, April 1982, p. 20

Xavier Girard, "Un Regard autre II: Galerie Farideh
Cadot," *Art Press*, no. 59, May 1982, p. 48

Jean de Loisy, "L'Air du temps," *Flash Art*
(International), vol. 16, May 1982, pp. 56, 58

Laurent Pesenti, "Georges Rousse," *Artistes*,
no. 11, June-July 1982, pp. 37-38

Michel Nuridsany, "L'Euphorie," *Le Figaro*,
October 6, 1982, p. 26

"Georges Rousse, Biennale de Paris," *Axe Sud*,
Autumn 1982

Michel Nuridsany, "Georges Rousse, un baroque
flamboyant," *Le Figaro*, January 19, 1983, p. 26

Philippe Dagen, "Rousse," *Le Quotidien de Paris*,
January 20, 1983

Olivier Céna, "Expo," *Télérama*, no. 1724,
January 26, 1983

Geneviève Breerette, "Georges Rousse: Figures de
l'éphémère," *Le Monde*, January 27, 1983, p. 16

Maïten Bouisset, "Georges Rousse: Une Photogra-
phie pour un instant de peinture," *Le Matin*,
January 28, 1983, p. 36

Jean de Loisy, "New French Painting," *Flash Art*
(International), no. 110, January 1983, pp. 44-48

Michel Nuridsany, "Georges Rousse: Un Baroque
épris de synthèse," *Art Press*, no. 66, January
1983, pp. 28-29

Didier Arnaudet, "Georges Rousse," *Art Press*,
no. 70, May 1983, p. 48

Olivier Céna, "Une Fin de siècle est difficile,"
Télérama, no. 1729, March 1983

Georgina Oliver, "Georges Rousse: From Shambles to Success," *Images*, no. 10, April 1983, pp. 60-61

Didier Arnaudet, "Georges Rousse, C.A.P.C.," *Art Press*, no. 70, May 1983, p. 48

Patrice Bloch and Laurent Pesenti, "Georges Rousse, un timide sûr de lui," *Beaux-Arts Magazine*, no. 2, May 1983, pp. 82-87

Delphine Renard, "Georges Rousse, Farideh Cadot," *Flash Art* (International), no. 112, May 1983, p. 74

Brigitte Cornand, "Visions," *Actuel*, June 1983

Dorian Paquin, "L'Ultime création," *L'Officiel*, no. 692, May 1983, pp. 150-153

Hans-Peter Schwerfel, "Malen macht wieder spass," *Art, Das Kunst Magazin*, June 1983, pp. 84-93

Aude Bodet, "Entre chien et loup," *Cover*, no. 7, Spring 1983, p. 30

Michael Brenson, " 'Three French Artists' at Zabriskie Gallery," *The New York Times*, August 5, 1983, section C, p. 19

Andy Grundberg, "In the Arts: Critics' Choices," *The New York Times*, August 7, 1983, section 2A, p. 3

Kim Levin, "Three French Artists," *The Village Voice*, August 9, 1983, p. 56

Catherine Nadaud, "François Boisrond, Hervé di Rosa et Georges Rousse: Trois Peintres français à New York," *Les Nouvelles Littéraires des arts, des sciences et de la société*, September 7-13, 1983, pp. 38-39

Patrice Bloch, "Chaussures, artistes et compagnie," *Beaux-Arts Magazine*, no. 9, January 1984, p. 14

Jérôme Sans, "Georges Rousse," *Flash Art* (France), Spring 1984

Catherine Strasser, "Georges Rousse, Musée municipal," *Art Press*, no. 83, July-August 1984, p. 66

Mireille Descombes, "La Magie de Georges Rousse," *La Tribune de Genève*, September 23, 1984

Catherine Francblin, *Le Quotidien de Paris*, October 3, 1984

Christian Caujolle, "Georges Rousse, architecte, peintre, photographe," *Libération*, October 11, 1984

Philippe Piguet, "Promenades autour de Beaubourg," *Kanal*, October 1984

Catherine Strasser, "Georges Rousse, no escape, no tarrying," *Artefactum*, no. 6, November-December 1984, pp. 45-47

Catherine Flohic, "Georges Rousse: Biographie," *Eighty*, no. 5, November-December 1984, pp. 62-63

Catherine Strasser, "Résistance," *Eighty*, no. 5, November-December 1984, pp. 33-61

Markku Valkonnen, "Georges Rousse," *Helsingin Sanomat*, February 19, 1985

Olivier Céna, "L'Enlumineur de mémoire: Les Rêves éphémères de Georges Rousse," *Télérama*, May 1, 1985, p. 40

"Douze Artistes dans l'espace," *Art Press*, no. 94, July-August 1985, pp. 24-25

Jean Tourangeau, "Georges Rousse, *Graff*, Montréal," *Vanguard*, vol. 14, September 1985, p. 46

Luc Vezin, "Téléphone graffiti," *Art Press*, no. 95, September 1985, pp. 64-66

Gilles Daigneault, "Une Oeuvre montréalaise de Georges Rousse," *Le Devoir* (Montreal), October 18, 1985, p. 6

Jocelyne Lepage, "Un Drôle d'aventurier," *La Presse* (Montreal), October 19, 1985

"Espaces pièges," *Connaissance des Arts*, no. 405, November 1985, p. 6

Philippe Dagen, "Georges Rousse, le géomètre du trompe-l'oeil," *Le Monde*, January 1, 1986, p. 12

Mona Thomas, "Georges Rousse," *Galeries Magazine*, no. 11, April 1986, pp. 44-47

Jocelyne Lupien, "Georges Rousse ou la dérobade de l'anamorphose," *Parachute*, no. 42, March-May 1986, pp. 13-15

58 *Untitled (Sans titre).* Paris, 1982
Cibachrome print, 47¼ x 55"
Courtesy Galerie Farideh Cadot, Paris

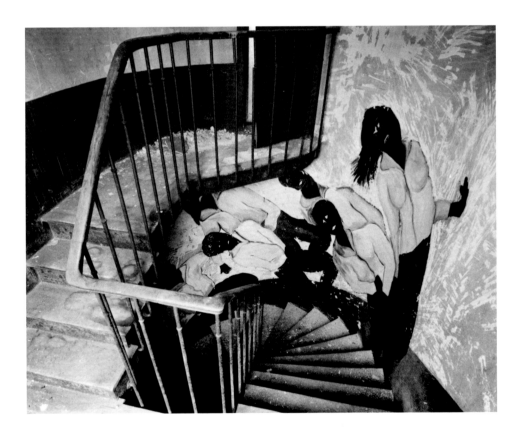

59 *Untitled (Sans titre).* Sydney, 1984
Cibachrome print, 50 x 60¾″
Collection Bijan Aalam, Paris

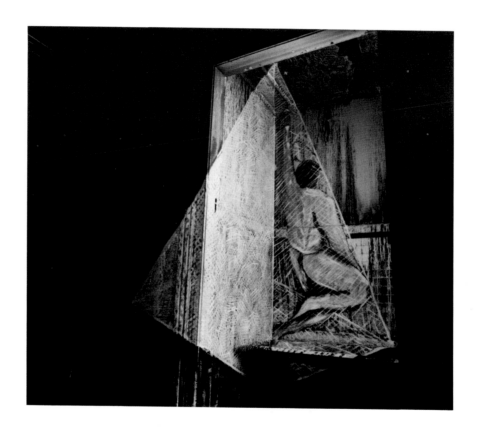

60 *Untitled (Sans titre)*. Paris, 1984
Cibachrome print mounted on wood, 78¾ x 102⅜"
Collection C.A.P.C. Musée d'Art Contemporain,
Bordeaux

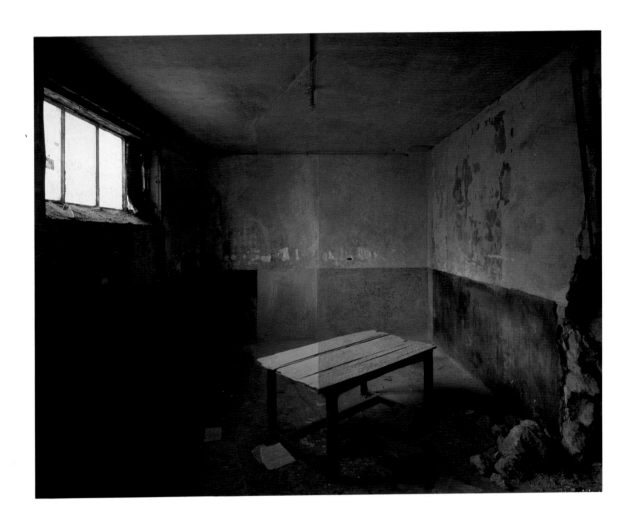

61 *Untitled (Sans titre).* Bercy, 1985
Cibachrome print mounted on aluminum, 71 x 94½″
Courtesy Farideh Cadot, Paris

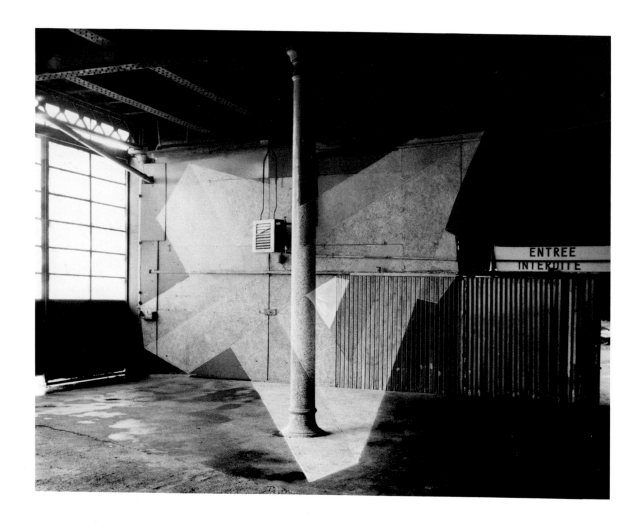

62 *Untitled (Sans titre).* Rome, 1985
Cibachrome print mounted on aluminum, 71 x 94½"
Collection Fonds National d'Art Contemporain, Paris;
Courtesy Galerie Farideh Cadot, Paris

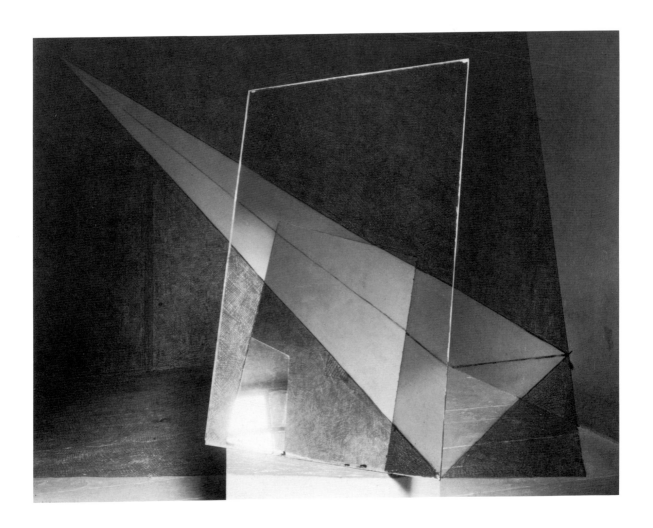

63 *Untitled (Sans titre).* Geneva, 1985
 Cibachrome print mounted on aluminum, 71 x 94½″
 Courtesy Galerie Farideh Cadot, Paris

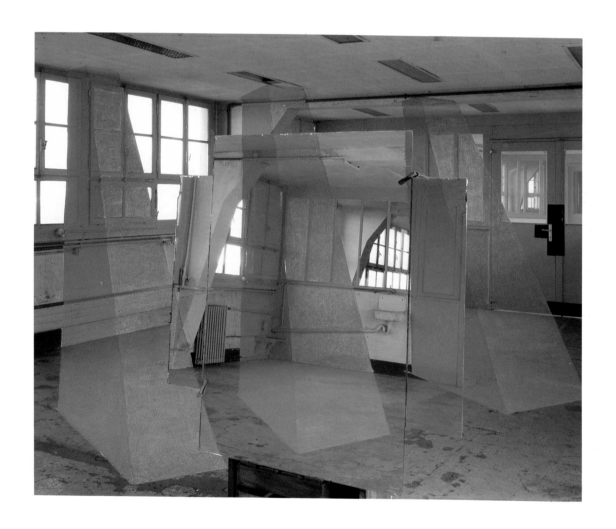

64 *Untitled (Sans titre)*. Bercy, 1985
Cibachrome print mounted on aluminum, 71 x 94½″
Private Collection

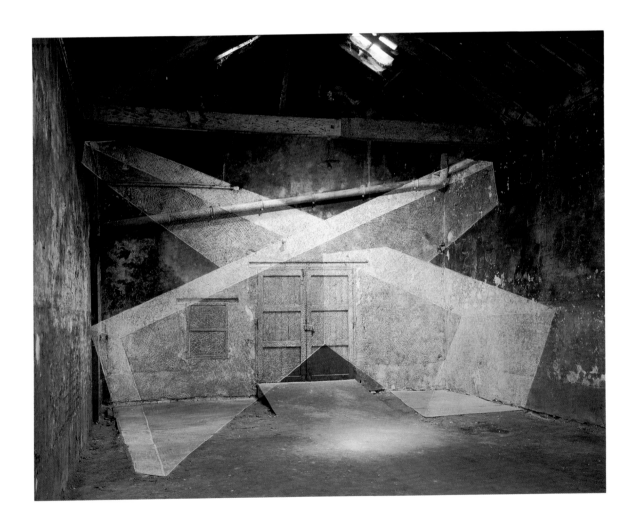

65 *Untitled (Sans titre)*. Montreal, 1985
Cibachrome print mounted on aluminum, 71 x 94½″
Collection Georges Pompidou Art and Culture
Foundation, New York

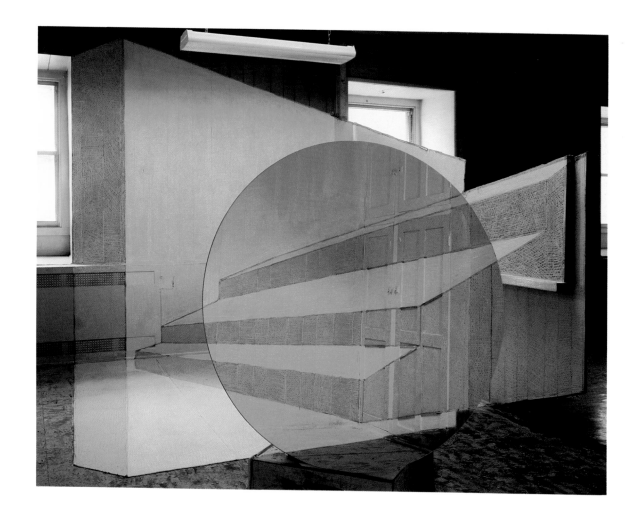

66 *Untitled (Sans titre).* Arles, 1986
Cibachrome print mounted on aluminum,
47¼ x 102⅜"
Collection Musée Réattu, Arles

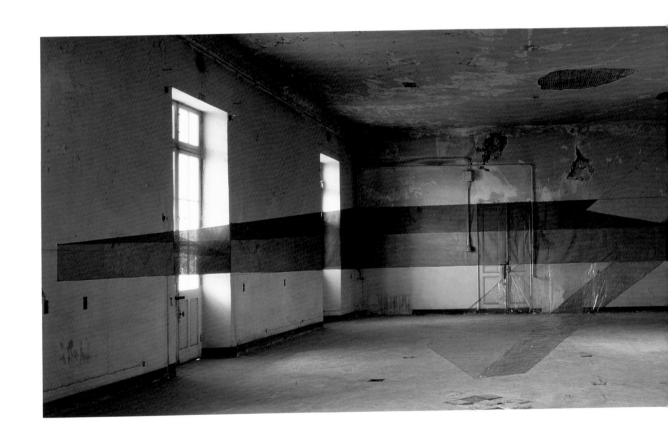

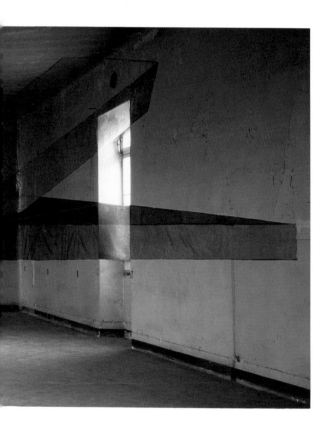

Patrick Tosani

To make a photograph means to freeze an instant of time. This is what Patrick Tosani accomplishes both literally and figuratively in his photographs of ice cubes. In an early series dating from 1982-83 (see cat. no. 67), Tosani uses ice as both physical reality and metaphor. Tiny plastic figures posed in states of motion—skiing, jumping, diving, dancing, mountain-climbing—are immobilized in ice cubes. These blocks of ice are thus transformed by suggestion into mountains, swimming pools or ski slopes, and the irregularities of their surfaces impart a dynamism and tactility to their otherwise inert forms. The artist photographs the figurines, which are set against brightly colored monochromatic backdrops, at close range, and enlarges the images to a size of 120 x 170 centimeters. In so doing, he freezes the activity of these small figures. Only the ice shows signs of movement, as it begins to melt. Though the melting process suggests release for the figurines, the act of photographing them has captured them in their frozen states forever. And moreover, paradoxically, although they are posed as if in motion, they are also "frozen" in their plastic form. They are suspended in a moment of time.

The seeming simplicity of Tosani's subjects disguises more complex problems at hand. The artist tells us much about the nature of photography, the nature of reality and the relationship between the two, using ice as a metaphor. The ice is translucent and thus exposes some elements of these frozen scenes, yet pockets of opacity disfigure or hide parts thereof. Ice is destined to disappear. Existence, too, is transitory. Photography can capture the ephemeral by suspending time, but the reality of photography is fictive: it exposes, but what it shows may be only partial and indeed may be false.

"To record time and release from its hold, if only for a moment, fragments of reality which soon will also succumb to it, this is the cycle that determines ... the evolution of Patrick Tosani's work."[1]

Tosani carries over this idea of reading an image into a series of portraits executed in 1984-85 (see cat. nos. 71, 72). For this group of works, Tosani projects slides of portraits, deformed beyond recognition by the out-of-focus lens and diffused light of the projector, onto pages of braille. Some of the braille characters have been flattened, creating a varied surface, and the paper has been given additional texture with a coat of paint. Tosani then photographs these projected images and presents them in the format of a 130 x 100 centimeter print.

While recognizable generically as portraiture, one cannot read any of the features or expressions of these faces. The expressivity of these portraits, like Francis Bacon's contorted and featureless heads, comes from another source, in this instance the raised dots. Despite the obliteration of physiognomy, each face has its own identity and individuality that is drawn not only from the braille characters, but also from the subtle variations in color, grain and focus. Tosani is asking us in essence to read these features, as one reads a page of writing. He thus redefines portraiture as something that goes beyond representation and expression to include tactility and the world of visual signs. Yet even the tactility is undermined: to read braille, we must touch it, and this is impossible because the relief loses its function as a tactile language on the glossy and smooth surface of the photograph.

In his most recent body of work, Tosani again uses water as his medium, but this time in its liquid state, as a steady stream of falling rain. In *The*

Rain (La Pluie) (cat. no. 73), the artist gives definition to the shape of rainfall: it acquires a regularity, an edge that is impossible to isolate in its natural, fluid state. He carries this artifice one step further in subsequent works by interrupting the flow of water with plexiglass punctuation marks and numerical signs. The illusion created is that of the rain itself forming these symbols, rather than that of an intervening object disrupting the pattern of its fall. Each picture functions on three levels: the title is the literal verbal equivalent of the action in the photograph; the photograph serves as the visual translation or description of this title; and the photograph, finally, stands independently as a work of art. For example, in *The Rain Between Parentheses (La Pluie entre parenthèses)* (cat. no. 76), the title suggests that the word "rain" is bracketed by parentheses, and indeed the photograph depicts the image of rain in exactly this state. In this play between plastic and literary form, the poetry of the work emerges. The artist has again captured the fugitive in a statement of elegant simplicity.

1. Jean de Loisy, *Patrick Tosani*, 1983, unpaginated.

Biographical Information

Born in Boissy l'Aillerie, Val d'Oise, September 28, 1954

Ecole Spéciale d'Architecture, Paris, 1973-79

Lives and works in Paris

Selected Group Exhibitions

Galerie de la Bibliothèque Nationale, Paris, *Architectures*, June 28-August 26, 1978

Galerie R.C. des Fossés, Saint Etienne, May 7-22, 1982

Association pour un Lieu de Création, Paris, October 2-24, 1982

Association Tours-Art Vivant (organizer), *France-Tours, art actuel: Première Biennale d'art contemporain*, Centre de Création Contemporaine, Tours, April 22-May 29, 1983. Catalogue with texts by Jean-Christophe Ammann, Marie-Claude Beaud, Michel Giroud, Giovanni Joppolo, Alain-Julien Laferrière, Jean de Loisy and Bernard Lamarche-Vadel

Musée Sainte-Croix, Poitiers, *Photographies de la collection Bernard Lamarche-Vadel*, May-June 1983. Catalogue with texts by A. Class and Bernard Lamarche-Vadel

Association Base Internationale, Villeurbanne, *La Nuit*, June 1983. Catalogue

Musée National d'Art Moderne, Centre Georges Pompidou, Paris, *Images fabriquées*, February 10-March 13, 1983 (Tosani not included in Paris show). Catalogue with text by Alain Sayag. Traveled to Musée des Beaux-Arts, Nantes, November 4-December 23; Musée d'Art Actuel, Hasselt, Belgium, June 8-July 8, 1984

F.R.A.C. Pays de la Loire, Fontevraud (organizer), *L'Art à l'oeuvre*, Ecole des Beaux-Arts, Angers, January 13-February 3, 1984; Espace Graslin, Nantes, June

F.R.A.C. Aquitaine- Midi Pyrénées- Languedoc-Roussillon (organizer), *Collections*, Casa Velázquez, Madrid, February 18-March 6, 1984; Palacio de la Longa, Saragossa, March 31-April 15; Palau Meca, Barcelona, May 22-June 24. Catalogue with text by G. Mora

F.R.A.C. Pays de la Loire, Fontevraud (organizer), *4 Festival de l'image*, Collégiale Saint-Pierre, Le Mans, October 8-28, 1984. Catalogue with text by Jean de Loisy

F.R.A.C. Pays de la Loire, Fontevraud (organizer), *I Ateliers internationaux de Fontevraud*, Abbaye Royale de Fontevraud, October 27-December 11, 1984. Catalogue with texts by Michel Enrici, Bernard Martin et al.

Bibliothèque Nationale, Paris (organizer), *La Photographie créative*, Pavillon des Arts, Paris, November 24, 1984-January 20, 1985. Catalogue with text by Jean-Claude Lemagny

Musée National d'Art Moderne, Centre Georges Pompidou, Paris, *Photographies contemporaines en France*, November 28, 1984-January 27, 1985. Catalogue with texts by Agnès de Gouvion St. Cyr and Alain Sayag. Traveled in Yugoslavia, 1985-86

F.R.A.C. Aquitaine, Bordeaux (organizer), *Aux Poteaux de couleur*, Musée Marzelles, Marmande, February 10-March 10, 1985. Catalogue with text by Jean-Marie Touratier

Fondation Cartier, Jouy-en-Josas, *Accrochage*, May 1985

Association Pratiques Publiques, Rennes (organizer), *Portraits de l'artiste*, Bibliothèque Inter-Universitaire, Rennes, December 3-17, 1985

Centre National de la Photographie, Paris (organizer), *Identités*, Palais de Tokyo, Paris, December 18, 1985-February 24, 1986. Catalogue with texts by Ch. Féline, M. Frizot, S. July and J. Sagne

Fondation Cartier, Jouy-en-Josas, *Sur les murs*, February 23-May 4, 1986. Catalogue

Fondation Nationale des Arts Graphiques et Plastiques, Paris, F.R.A.C. Pays de la Loire, Fontevraud (organizers), *Ateliers internationaux des Pays de la Loire, deux ans d'acquisitions*, Fondation Nationale des Arts Graphiques et Plastiques, Paris, May 7-June 8, 1986. Catalogue with text by Mario Toran

A.F.A.A. (Association Française d'Action Artistique), Paris (organizer), *Constructions et fictions*, Fondazione Scientifica, Querini-Stampalia, Venice, June 20-July 30, 1986; Institut Français, Naples, October 1-30. Catalogue with text by Régis Durand

Selected One-Man Exhibitions

Espace Avant-Première, Paris, June 1-26, 1982

Galerie Liliane et Michel Durand-Dessert, Paris, May 25-July 9, 1983; May 30-June 29, 1985

Association l'Oeil Permanent, Nantes (organizer),

Patrick Tosani, Palais de la Bourse, Nantes. December 15, 1983-January 7, 1984; Musée Municipal de La Roche-sur-Yon, February 4-March 13; Athénéum and Le Consortium, Dijon, April 17-30; Palais des Congrès et de la Culture, Le Mans, May 3-29. Catalogue with text by Jean de Loisy

Gallery Taka Gi, Nagoya, April 1-20, 1986

Galerie Christian Laune, Montpellier, May 24-June 28, 1986

Selected Bibliography

Jean de Loisy, "Patrick Tosani: Photographe de glaçons," *Art Press*, no. 67, February 1982, p. 35

Patrice Bloch and Laurent Pesenti, "F.I.A.C., Patrick Tosani," *Beaux-Arts Magazine*, no. 6, October 1983, pp. 58-59

Bernard Blistène, "Patrick Tosani, Galerie Durand-Dessert," *Flash Art* (France), no. 1, Fall 1983, p. 46

Carol Rio and Stéphanie Taranne, "Premiers Ateliers internationaux d'art vivant," *Art Press*, no. 88, January 1985, p. 60

Mona Thomas, "Paris: Patrick Tosani," *Beaux-Arts Magazine*, no. 25, June 1985, p. 93

Elisabeth Vedrenne, "Une Consécration, Patrick Tosani," *Décoration Internationale*, no. 82, June 1985, p. 10

Philippe Nottin, "Patrick Tosani, Portraits," *Kanal*, no. 12-13, Summer 1985, p. 44

Philippe Piguet, "Patrick Tosani: A fleur de peau," *L'Art Vivant*, no. 12, Summer 1985, p. 13

Régis Durand, "Patrick Tosani, Galerie Durand-Dessert," *Art Press*, no. 95, September 1985, pp. 68-70

Régis Durand, "Identités, Desdéri au photomaton, Palais de Tokyo," *Art Press*, no. 100, February 1986, p. 90

Jean-Pierre Bordaz, "Montpellier: Patrick Tosani," *Beaux-Arts Magazine*, no. 36, June 1986, p. 94

Philippe Piguet, Montpellier, Patrick Tosani," *L'Oeil*, no. 371, June 1986, p. 86

67 *The Diver (Le Plongeur).* 1982
 Color photograph, 47½ x 67"
 Courtesy Galerie Liliane et Michel Durand-Dessert,
 Paris

68 *The White Arenas (Les Arènes blanches).* 1983
Color photograph, 47½ x 67"
Courtesy Galerie Liliane et Michel Durand-Dessert,
Paris

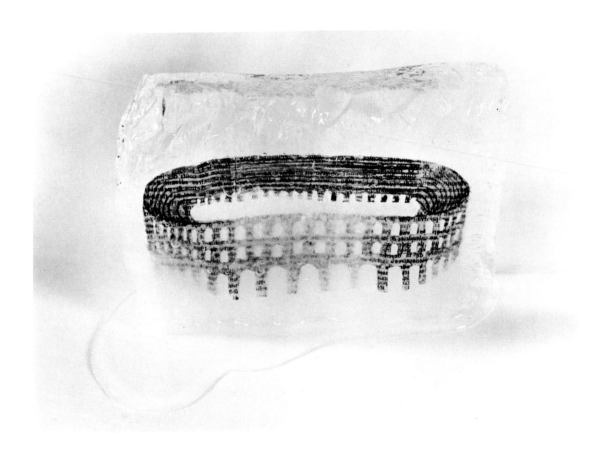

69 *The Temple (Le Temple).* 1983
Color photograph, 47½ x 67"
Courtesy Galerie Liliane et Michel Durand-Dessert,
Paris

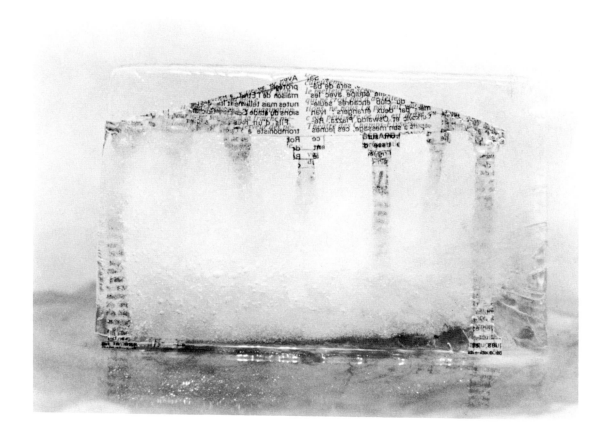

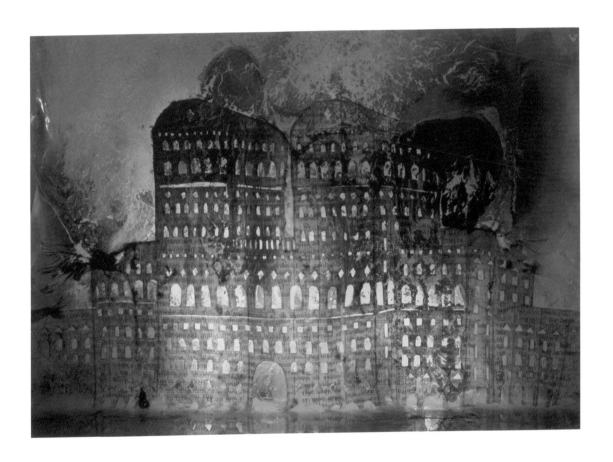

70 *Palace (Palais).* 1983
 Color photograph, 47½ x 67"
 Collection Michel Makarius, Paris

71 *Portrait No. 1.* 1984
Color photograph, 51⅛ x 39⅜″
Courtesy Galerie Liliane et Michel Durand-Dessert,
Paris

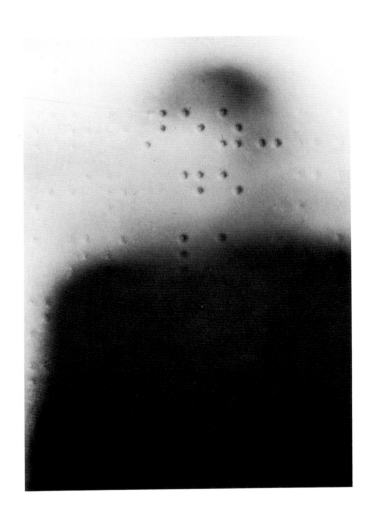

72 *Portrait No. 3.* 1984
Color photograph, 51⅛ x 39⅜″
Courtesy Galerie Liliane et Michel Durand-Dessert,
Paris

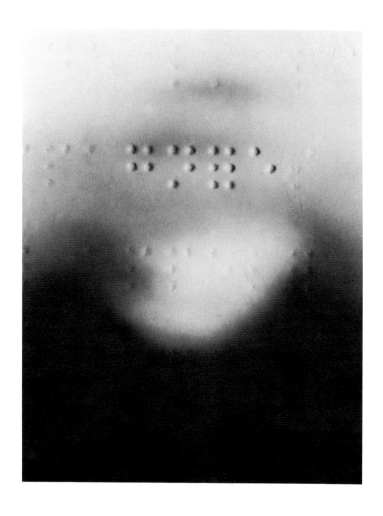

73 *The Rain (La Pluie).* 1986
Cibachrome print, 47½ x 62½″
Courtesy Galerie Liliane et Michel Durand-Dessert,
Paris

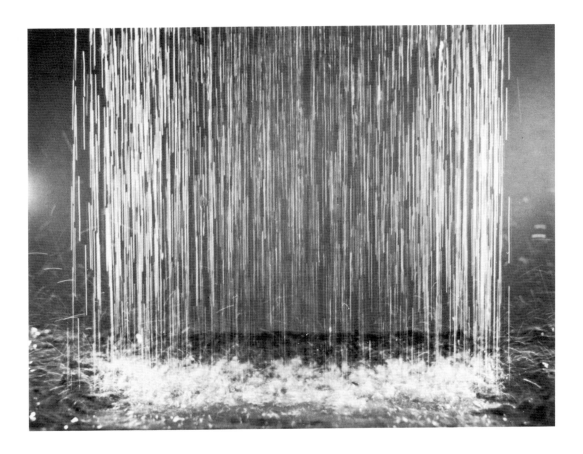

74 *The Rain Plus (La Pluie plus)*. 1986
Cibachrome print, 47½ x 62½"
Courtesy Galerie Liliane et Michel Durand-Dessert,
Paris

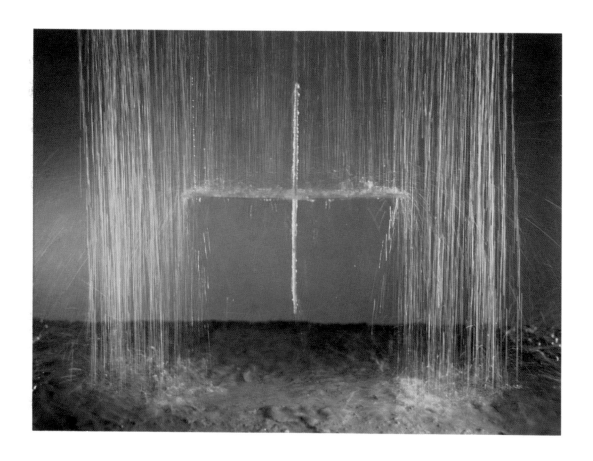

75 *The Rain Comma (La Pluie virgule).* 1986
 Cibachrome print, 47½ x 62½"
 Courtesy Galerie Liliane et Michel Durand-Dessert,
 Paris

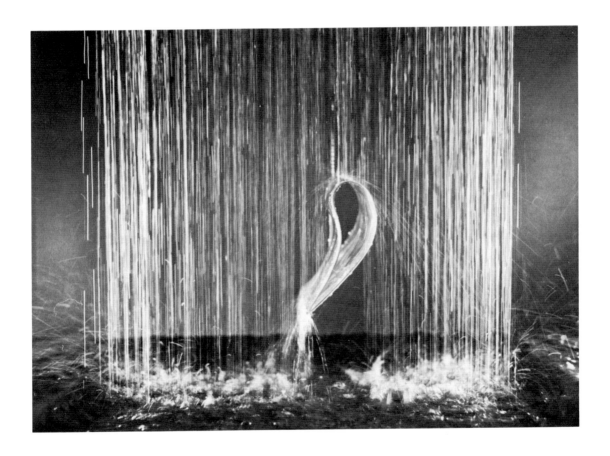

76 *The Rain Between Parentheses (La Pluie entre parenthèses)*. 1986
Cibachrome print, 47½ x 62½"
Courtesy Galerie Liliane et Michel Durand-Dessert, Paris

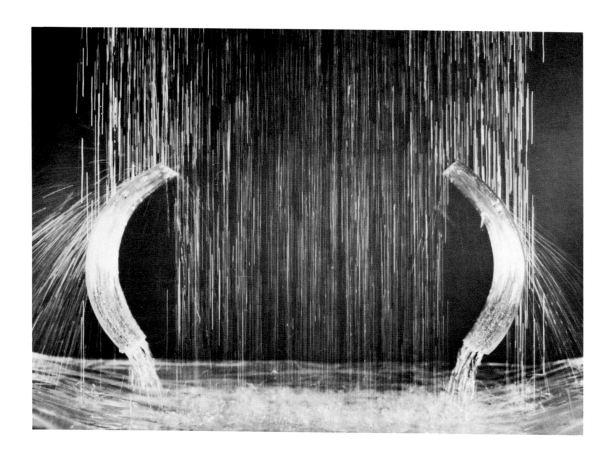

Daniel Tremblay

Daniel Tremblay died tragically, the victim of an automobile accident, on April 9, 1985, at the age of thirty-five. Although the artistic legacy he left is comparatively small, it is nonetheless rich in quality, and significant in terms of the impact it has had and continues to have on artists of his generation.

Tremblay's oeuvre partakes of an aesthetic prevalent among the emerging artists in France today, which focuses on the "cult of the object." The work of these artists manifests close affinities with New British Sculpture, whose adherents, among them Tony Cragg, Bill Woodrow and Richard Deacon, use cast-off industrial or domestic objects or materials in inventive combinations to create sculptural images. Tremblay's familiarity with this aesthetic was gained first-hand since he spent two years in England studying at the Royal College of Art. Yet despite similarities in orientation, Tremblay approached and manipulated the object in a strikingly original and individual manner, as do his contemporaries. What he shared with them was a custom of referring to and reinterpreting a variety of twentieth-century precedents for using the object in art. In this regard, Marcel Duchamp's elevation of common objects to the status of art in his Readymade sculptures was of pivotal importance to Tremblay and continues to be so to his peers. The same is true of the redemption and consequent magnification of the importance of discarded industrial materials of Les Nouveaux Réalistes; the Surrealists' incongruous juxtaposition of seemingly unrelated objects; the Pop Artists' passion for the banal image and the elevated position they accorded everyday or commonplace objects; the Minimalists' use of industrial or mass-produced materials; and the Arte Povera group's tendency toward mythologization.

Tremblay used readily obtainable materials, for example slate, linoleum, rubber, marble and synthetic grass, in tandem with unexpected objects such as rakes, wooden ducks or other birds, toy airplanes and fake pearls. Although the materials do not have histories of uses, they are nonetheless invested with meaning by virtue of their unique properties. In combining them to create the work of art, Tremblay transformed them through the succession of poetic associations that arise from their functions, materials, forms, colors and textures. The suggestive qualities of the materials rather than the objects themselves were particularly compelling for him. For example, he associated the blackness of rubber with night, and used it as a ground for images of dreams and sleep. At the same time, he was attracted by the matte aspect of its surface, and played off this quality by studding it with pearls, whose luster and preciousness provide a startling counterpoint to the dull finish and crudity of the rubber. The way the rubber both absorbs and reflects light is another property of this essentially anti-aesthetic material that the artist found irresistible. Tremblay continually manipulated the oscillation between the concrete reality of his objects and materials and the new identity that they acquired through transformation.

Although Tremblay produced three-dimensional works, he considered himself primarily a sculptor of bas-relief. He also executed installations, made in direct relation to particular spaces and their architecture, but in this context he considered space a material rather than a place: "An installation is a game where space intervenes as a material with its own potentials which I try to discover."[1]

What is most striking about Tremblay's oeuvre,

no matter what the chosen medium, is its poetic groundwork. He contended that the simplest statement could be the most eloquent; indeed, his artistic origins were in Minimalism, and although his course subsequently deviated significantly from that idiom, his choice of subject and manipulation of form retained a simple and straightforward quality, not reductive, yet displaying an economy of means. In some ways, his images read as signs or symbols —a crescent shape evokes the moon, for example. But the image's associations belie, even transcend its apparent artlessness. The crescent moon is loaded with an expressive poetry that is far-reaching, just as his images of sleep, a kiss or a starry night have metaphoric possibilities that extend beyond the realm of mere representation. Tremblay spoke of the transcendence of his objects: "I would like . . . to find in objects, in materials, those aspects that reveal another vision of things, more poetic, that is, by slightly modifying them without changing their original function, to open their other emotional dimensions. For example the rake continues to rake, but associated with the stars, it provokes other reveries that suddenly become evident. I would like my works to be moving."[2]

In the course of the years 1981 to 1985, Tremblay's oeuvre evolved in an increasingly abstract and simplified direction. His earlier works relied more on a dialogue between the parts that made up the composition, and as such had a stronger narrative quality. Just prior to his death, the artist exhibited a series of works executed in rubber, which borrowed from his established repertory of images— profiles, reclining figures, starry nights. Here, Tremblay carved deep crevices out of the thick rubber mats to reveal the blue, pink or yellow colored lay-

ers that were buried within, and to create the simple and evocative contours of the pieces. In retrospect, the peaceful reclining profile of *Pink Moon (Rose Lune)* (cat. no. 84) or the rubber head resting on a wood support with the moon above of *Untitled (Sans titre)*, 1985 (cat. no. 86), seem to be omens as if Tremblay had presaged his own death. They reveal the artist's sensitivity to the more sober and tragic side of life, which always seems to lie beneath the surfaces of his depictions of innocent sleep or his nighttime skies that evoke the cosmos and the infinite. If the playfulness of his images is at times reminiscent of nursery rhymes, there is also an uneasy feeling, a more serious dimension to these flights of fantasy.

One critic, writing on Tremblay's work, said, "Who still believes that the proliferation of industrial objects has killed the poetry of things?"[3] This statement captures the essence of the artist's accomplishment, and as such could serve as his epitaph.

1. *Soyons sérieux*, 1985, p. 42.
2. *Truc et troc, leçons de choses*, 1983, p. 104.
3. Strasser, *Halle Sud*, 1985, p. 1.

Biographical Information

Born in Angers, Anjou, March 7, 1950
Royal College of Art, London, 1977-80
Grant, Henry Moore Foundation, London, 1978
Teacher, sculpture, Ecole des Beaux-Arts de Mulhouse, France, 1980-85
Died in Angers, April 9, 1985

Selected Group Exhibitions

Musée d'Art Moderne de la Ville de Paris, *XI Bien-*

nale de Paris, September 22-November 2, 1980. Catalogue

A.R.C., Musée d'Art Moderne de la Ville de Paris, Ateliers 81/82, November 26, 1981-January 3, 1982. Catalogue with texts by Suzanne Pagé and Didier Semin

Institut Culturel Italien, Paris, 1981

Chartreuse de Villeneuve-les-Avignon, De la cave au grenier, July 10-August 7, 1982

A.R.C., Musée d'Art Moderne de la Ville de Paris, Truc et troc, leçons de choses, January 27-March 6, 1983. Catalogue with texts by Catherine Ferbos, Jean-Hubert Martin, Suzanne Pagé and Beatrice Parent

Association Tours-Art Vivant (organizer), France-Tours, art actuel: Première Biennale d'art contemporain, Centre de Création Contemporaine, Tours, April 22-May 29, 1983. Catalogue with texts by Jean-Christophe Ammann, Marie-Claude Beaud, Michel Giroud, Giovanni Joppolo, Alain-Julien Laferrière, Bernard Lamarche-Vadel and Jean de Loisy

A.F.A.A. (Association Française d'Action Artistique), Paris (organizer), Arte Francés Contemporaneo, Museo Sivori, Buenos Aires, July 13-August 3, 1983; Museo Nacional de las Artes Plásticas y Visuales, Montevideo, August 10-September 4; Museo del Banco Central, Lima, September 24-October 20; Casa de la Cultura, La Paz, November

Art Prospect, Paris (organizer), Réseau Art 83, posters and billboards commissioned for public display in France, August 1-15, 1983

Fondation Elf Aquitaine (organizer), Paris, Musée du Trocadéro, Paris, 1983

Fisher Art Gallery, University of Southern California, Los Angeles, French Spirit Today, March 19-April 21, 1984. Catalogue with texts by Jean-Louis Froment and Catherine Strasser. Traveled to Museum of Contemporary Art, La Jolla, California, June 16-August 3

F.R.A.C. Pays de la Loire, Fontevraud (organizer), I Ateliers internationaux de Fontevraud, Abbaye Royale de Fontevraud, October 27-December 11, 1984. Catalogue with texts by Michel Enrici, Bernard Martin et al.

F.R.A.C. Aquitaine, Bordeaux (organizer), Lumières et sons, Château de Biron, Dordogne, June 23-September 22, 1984

Frederick S. Wight Art Gallery, University of California, Los Angeles, Manipulated Reality: Image and Object in New French Sculpture, February 5-March 24, 1985. Catalogue with texts by Jean-Louis Froment, Pierre Restany and Edith A. Tonelli

Espace Lyonnais d'Art Contemporain, Lyon, Soyons sérieux, February 28-May 14, 1985. Catalogue with texts by Bernadette Bost, Alain Charre, Michel Nuridsany, Catherine Strasser et al.

Atelier des Enfants, Centre Georges Pompidou, Paris, Objets en dérive, 1985

Fondation Nationale des Arts Graphiques et Plastiques, Paris, Créations pour un F.R.A.C. (Pays de la Loire), April 29-June 8, 1986

Selected One-Man Exhibitions

Galerie Farideh Cadot, Paris, Un Regard autre, September 15-October 15, 1981; June 17-July 8, 1983; Sculptures récentes, March 22-April 20, 1985

Musée de Toulon, Daniel Tremblay, December 2, 1982-January 9, 1983. Catalogue with texts by Marie-Claude Beaud and Guillemette Coulomb

Selected Bibliography

Maïten Bouisset, "Les Jeunes au banc d'essai," Le Matin, October 6, 1981

Catherine Strasser, "Galerie Farideh Cadot, un regard autre," Art Press, no. 53, November 1981, p. 38

Jean-Marc Poinsot, "New Painting in France," Flash Art (International), no. 108, Summer 1982, pp. 40-44

Jean de Loisy, "New French Painting," Flash Art (International), no. 110, January 1983, pp. 44-48

Daniel Bombert, "Daniel Tremblay, Bernard

Faucon: Musée de Toulon," *Art Press*, no. 67, February 1983, p. 49

Xavier Girard, "Neue Figuration in Frankreich," *Kunstforum International*, vol. 59, March 1983, pp. 39-47

Maïten Bouisset, "L'Un est anglais, l'autre pas," *Le Matin*, June 17, 1983, p. 38

Franck Maubert, "Daniel Tremblay," *L'Express*, June 24-30, 1983, p. 160

Hans-Peter Schwerfel, "Malen macht wieder spass," *Art, Das Kunst Magazin*, no. 6, June 1983, pp. 84-93

Patrice Bloch and Laurent Pesenti, "Daniel Tremblay: Accumulations oniriques," *Les Nouvelles Littéraires des arts, des sciences et de la société*, September 14-20, 1983, p. 54

Xavier Girard, "Réseau art 83/art prospect," *Art Press*, no. 76, December 1983, p. 60

Anne Tronche, "Daniel Tremblay," *Opus International-83*, Winter 1983, pp. 22-23

Catherine Strasser, "Histoires de sculpture/ Lumières et sons," *Art Press*, no. 84, September 1984, p. 47

"Fondation Jourdon, l'hôtel revisité," *City Magazine International*, no. 6, December 1984

Henri-François Debailleux, "Paris: Daniel Tremblay," *Beaux-Arts Magazine*, no. 23, April 1985, p. 87

Catherine Strasser, "Daniel Tremblay, Mirage," *Halle Sud*, no. 8, April 1985, p. [1]

Christian Schlatter, "Materials Gone Crazy," *Flash Art* (International), April-May 1985, pp. 52-56

Anne Dagbert, "Daniel Tremblay, Galerie Farideh Cadot," *Art Press*, no. 92, May 1985, pp. 64-66

Catherine Strasser, "Daniel Tremblay, apparence d'espace," *Art Press*, no. 94, July-August 1985, p. 27

Catherine Grout, "Sculpture in France," *Flash Art* (International), no. 125, December 1985-January 1986, pp. 66-69

77 *Untitled (Sans titre).* 1983
Brushes and sickle, 24 x 54¾"
Collection Bijan Aalam, Paris

78 *Untitled (Sans titre).* 1981
 Installation, charcoal on cardboard with paper stars
 Collection Volvo-France

79 *Untitled (Sans titre).* 1982
Artificial turf, wooden stool and plastic goose with
acrylic paint, 118⅞ x 78¾″
Collection Musée de Toulon

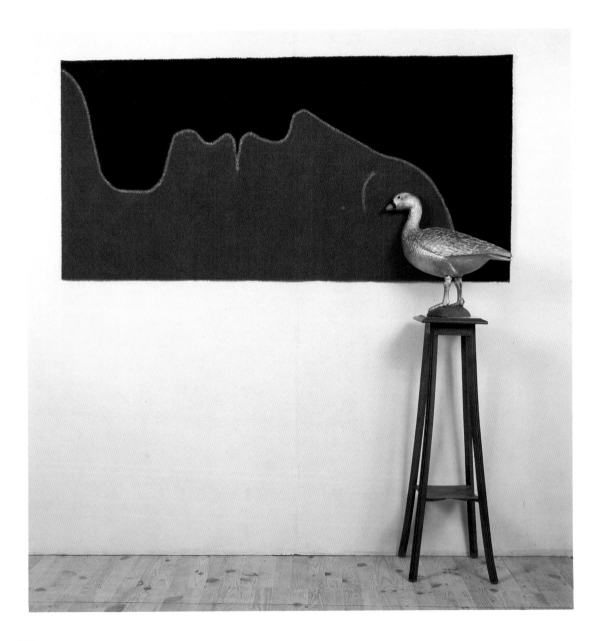

80 *Untitled (Sans titre).* 1981
Bristles and plastic bird with acrylic paint, 19⅝"
diameter
Collection Musée de Toulon

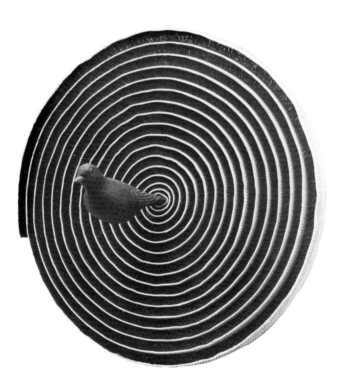

81 *Crows (Corbeaux).* 1983
Linoleum and rhinestones mounted on wood with
two crows, 23⅝ x 59″

Collection Ethan J. & Sherry Remez Wagner,
Sacramento, California

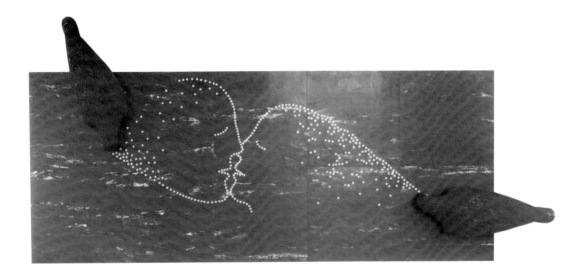

82 *Piece of Night (Morceau de nuit).* 1984
Rubber and pearls, 17¾ x 41¼″
Collection Jean-François and Françoise Echard, Paris

83 *Evening Butterflies (Papillons du soir).* 1985
Rubber, 28⅜ x 71⅜″
Collection Marie-Claude Beaud

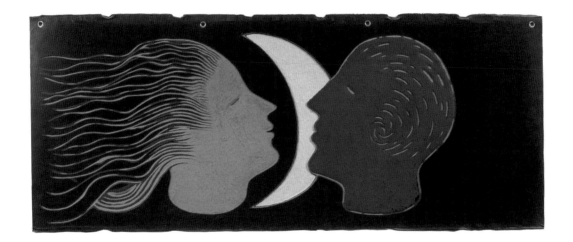

84 *Pink Moon (Rose Lune).* 1985
Rubber, 28⅜ x 71⅜"
Courtesy Galerie Farideh Cadot, Paris

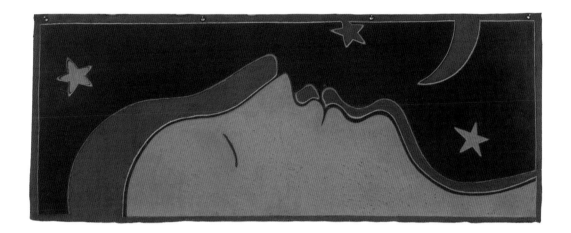

85 *Moon and its Reflection (Lune et son reflet).* 1985
Installation, charcoal and bags of charcoal
Courtesy Galerie Farideh Cadot, Paris

86 *Untitled (Sans titre).* 1985
 Rubber and acrylic paint on wood, 47¼ x 23⅝ x 16½″
 Private Collection

Photographic Credits

Color

Martine Aballéa: cat. nos. 2, 4

Hughes Bigo: cat. no. 9

Pierre Carbuccia: cat. no. 20

Bernard Faucon: cat. nos. 33-38

Yves Gallois: cat. nos. 13, 14, 17, 18, 23

François Lagarde: cat. no. 19

André Morin, Paris: cat. nos. 29, 30, 32, 40, 44-48,
77, 79, 83, 84

André Pelle: cat. nos. 49, 52, 53, 56

Georges Rousse: cat. nos. 60, 63-66

Patrick Tosani: cat. nos. 67, 70, 74

Black and White

Martine Aballéa: cat. nos. 1, 3, 5-8

Donage: cat. nos. 10, 11

Galerie Arlogos, Nantes: cat. no. 12

Yves Gallois: cat. nos. 15, 16, 21, 22

Roberto Manzotti: cat. no. 57

André Morin, Paris: cat. nos. 26-28, 31, 39, 41-43,
78, 80-82, 85, 86

André Pelle: cat. nos. 50, 51, 54, 55

Georges Rousse: cat. nos. 58, 59, 61, 62

Ivan Dalla Tana: cat. nos. 24, 25

Patrick Tosani: cat. nos. 68, 69, 71-73, 75, 76

Exhibition 86/9

4,500 copies of this catalogue, designed by Malcolm
Grear Designers, Inc., and typeset by Schooley
Graphics/Craftsman Type, have been printed by
Eastern Press in September 1986 for the Trustees
of The Solomon R. Guggenheim Foundation on the
occasion of the exhibition **Angles of Vision: French
Art Today, 1986 Exxon International Exhibition.**